the making of
great photographs

APPROACHES AND TECHNIQUES OF THE MASTERS

Eamonn McCabe

the making of
great photographs

APPROACHES AND TECHNIQUES OF THE MASTERS

D&C
David and Charles

A DAVID & CHARLES BOOK

David & Charles is a subsidiary of F+W (UK) Ltd.,
an F+W Publications Inc. company

First published in the UK in 2005
First paperback edition 2005

Text copyright © Eamonn McCabe 2005

Distributed in North America
by F+W Publications, Inc.
4700 East Galbraith Road
Cincinnati, OH 45236
1-800-289-0963

A catalogue record for this book is available from the British Library.

ISBN 0 7153 2220 6 hardback
ISBN 0 7153 2156 0 paperback

Printed in China by SNP Leefung
for David & Charles
Brunel House Newton Abbot Devon

Commissioning Editor Neil Baber
Editor Charlotte Barton
Editorial Assistant Louise Clark
Art Editor Sue Cleave
Designer Jodie Lystor
Production Controller Kelly Smith

Visit our website at www.davidandcharles.co.uk

David & Charles books are available from all good bookshops; alternatively
you can contact our Orderline on 0870 9908222 or write to us at
FREEPOST EX2 110, D&C Direct, Newton Abbot, TQ12 4ZZ (no stamp
required UK mainland).

contents

documentary photography

introduction

Who can say what makes a great photograph? Does it have to be famous? Influential? By a well-known photographer? Undoubtedly there are great photographs taken every day that will never be seen by more than a handful of people. Some great photographers are best known for a picture that might not represent their greatest work. Opinions will obviously differ, but in this small selection all the images have been chosen from the collection of the National Museum of Photography Film and Television in Bradford, Yorkshire, so we can at least say that they may be 'great' inasmuch as they have been gathered together for posterity to represent the history and development of the medium and the leading figures in the story so far.

The choice was not an easy one and from such a large collection, another selection entirely could have been made, which would be equally valid. It is not the purpose of the book to declare the best photographs in the history

of photography, so nothing is meant by the inclusion or exclusion of any particular photographer or photograph. As a photographer, the fascination is in what can be learned from the way in which each image has been approached. What were the artistic and practical concerns of the time and, as modern photographers, what lessons can we learn from these pictures? Each photograph therefore becomes the starting point of a discussion.

It's equally difficult to categorize the nature of a photograph and although the book is presented in four chapters, the selection of a photograph as a 'landscape', 'portrait', 'documentary' or as 'art photography' must to some extent be considered arbitrary. One could argue that all of them are at some level 'art' and yet others would contest that in fact none of them are art at all – but photography.

Certain terms crop up again and again throughout the book concerning the

artistic movements that photographers aligned themselves with: Pictorialism, the Linked Ring, the Photo-Secession and so on. No artist or photographer works in isolation and so it is worth trying briefly to put into context the key developments in the history of photography and the arguments about how it should be approached, that have been raging since its beginnings.

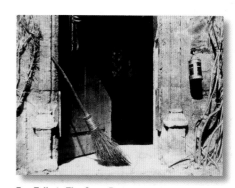

Fox Talbot, *The Open Door* (p43)

The earliest photograph in the book is William Henry Fox Talbot's *The Open Door*. One wonders what the meaning of the open door is, to whom the broom belongs, where everyone has gone, but recording an image at all

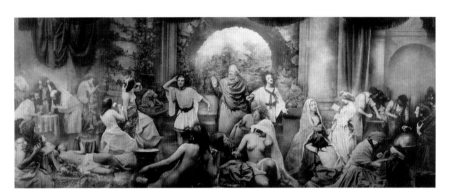

Rejlander, *The Two Ways of Life* (p93)

By the later 19th century, the photographic process had been sufficiently well conquered to give rise to the mass proliferation of photographic images of little artistic worth, provoking, once again, the old call that photography was not art but a scientific process. Photographers were therefore not artists but merely technicians or machine operators. A natural enough response to this was for art photographers to insist on their own intervention in the process. So began the period of Pictorialism. From George Davison's *The Onion Field* using a pinhole camera to achieve an impressionistic image, to Robert Demachy's intense working over of his

was amazing enough in the 1840s; the accurate rendering of complex subjects would have seemed remarkable then without any need to seek its meaning. It seems odd now to think that Talbot was so impressed by the democracy of photography, that it did not discriminate between elements in the frame but captured unimportant details with the same disinterested perfection as the main subject of the photograph.

The first artists of the photographic era attempted to align themselves with the best traditions of classical art with elaborate and painstaking images aping painting syles, such as Rejlander's *The Two Ways of Life* or Robinson's *Bringing Home the May*, but the over-elaboration was bound to bring a reaction and it did so, principally espoused by P H Emerson and his ideas of a 'naturalistic' photography, expressing the truth and immediacy of real life. Like the Impressionist painters he wanted to capture the atmosphere of a fleeting moment. Many did not agree with his ideas and a bitter row developed between the Emerson camp, increasingly championed by George Davison, and the devotees of sharp focus such as Rejlander and Robinson.

Davison, *The Onion Field* (p73)

Figure Study by etching the negative and using the gum bichromate development process (which allowed him to manually alter the print as it was developing), these picturesque and impression-like blurry images were in favour until about 1910.

Pictorialism in the UK was chiefly represented by the Linked Ring Brotherhood founded in 1892. With something of the flavour of the Pre-Raphaelite Brotherhood of painters, this was a breakaway group from the Photographic Society founded by such artists as George Davison and Henry Peach Robinson. The first American elected to the Ring was Alfred Stieglitz, who became the most important promoter of art photography in the United States over the coming decades. Forming his own breakaway group from the Camera Club of New York, his Photo-Secession took its name from the various 'secessionist' art movements in Europe, notably the Vienna Secession of Gustav Klimt and Egon Schiele. Photographers of the Photo-Secession

Coburn, *Vortograph* (p77)

such as Clarence White and Edward Steichen initially produced work of the 'fuzzy' Pictorialist type and Stieglitz promoted their photographs through his sumptuously produced magazine *Camera Work* and his own 291 Gallery in New York. But with the complex formal composition and social content of his image *The Steerage* in 1907, Stieglitz was the first to signal a new direction towards 'straight' photography, and the last issue of *Camera Work* in 1917 was devoted to the new uncompromising Modernist style of Paul Strand, including *The White Fence*.

The same year in England, Alvin Langdon Coburn was making his own Modernist experiments with his Cubist-inspired Vortographs, and in Europe, experiments in Modernism led to the uncompromising 'objectivity' of photographers like Albert Renger-Patzsch and images leaning towards Surrealism and abstraction like Brassaï's *Les Gouttes*. By the late 1920s in California, Group f.64, which included the photographers Ansel Adams and Edward Weston, took the 'pure' or 'straight' photograph to its logical conclusion with grand and technically

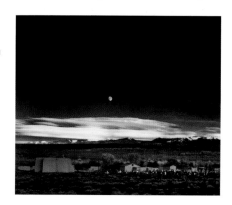

Adams, *Moonrise over Hernandez, New Mexico* (p71)

precise images taken on large 10×8in cameras. The name aptly describes their approach, f.64 being the smallest aperture available on their large-format cameras, necessary to obtain sharp focus throughout the picture.

Social documentary photography, which began in the late 19th century with the work of photographers like John Thomson and Thomas Annan, enjoyed a golden period in America in the 1930s. Lewis

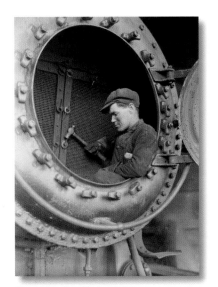

Hine, *Man in a Firebox* (p33)

Hine documented the life of workers and industry, and the government-sponsored Farm Security Administration project provided a platform for compelling photographs of depression-era America, the most famous of which is undoubtedly Dorothea Lange's *Migrant Mother*.

The antidote to Ansel Adams' grand scale photography came in the form of the 35mm Leica which was first introduced in the mid 1920s. This lightweight and practical tool encouraged and inspired a new type of documentary photography: photojournalism. Among the chief exponents of this new all-action photography was Robert Capa, earning worldwide fame for his dynamic images of the Spanish Civil War and the D-Day landings. Photojournalism remained crucial in the development of photography after World War II with the formation of photographic agencies such as Magnum, founded by Capa, Henri Cartier-Bresson, George Rodger and Chim Seymour and the continued success of illustrated magazines

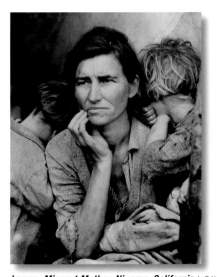

Lange, *Migrant Mother, Nipomo, California* (p21)

including *Picture Post* and *Life,* which made stars out of photographers like Bert Hardy, Kurt Hutton and Larry Burrows, all included here.

Judging the merit of an image or its contribution to the history of the medium becomes increasingly difficult the closer we come to our own era when arguments still rage as to the value of the work. This is particularly true where the emphasis is more on the concept

of an image or group of images (as is often the case with contemporary photography) rather than the aesthetic value of a single photograph or the technical excellence of its production. The most recent pictures in the book, by photographers such as Paul Caponigro, Fay Godwin and John Blakemore sit, less contentiously, in the tradition of the master photographer – aesthetic images executed with an undoubted mastery of technique. Another problem is that the use of photography by contemporary artists makes it increasingly difficult to even identify a distinction between photography and art or, put another way, between 'art photography' and 'art using photography'. David Hockney anticipated this trend using photographic snaps in his 'joiners', and his inclusion in this collection is perhaps fitting comment on the blurring of the line and an appropriate 'photograph' with which to end the book.

It has been a fascinating experience, in preparing this book, to discover the stories behind the images, to look closely at what the photographer was trying to achieve and how they went about doing it. From a photographer's point of view, there is a lesson to be learnt in every picture. It's unlikely that you would want to try to imitate the pictures exactly but 'recreating the effect', learning from the approach undertaken in each case, can be an inspiration and could take your own photography in all sorts of unexpected new directions. Good luck.

Caponigro, *Backlit Sunflower, Winthrop, Massachusetts* (p85)

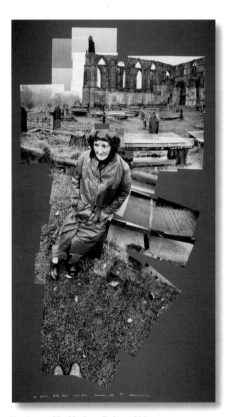

Hockney, *My Mother, Bolton Abbey, Yorkshire* (p133)

documentary
photography

frank meadow sutcliffe

Shadows in an Alleyway, *c.* 1905 platinum print

behind the image

This dramatic photograph of a woman on some steps in Whitby in Yorkshire is not an easy one to get right, even today. The bright sunlight bleaches the top of the steps and the buildings behind her, whilst the sides of the buildings leading up to the steps are in deep shadow, providing great contrast, but huge exposure problems.

This image shows Sutcliffe at his most creative and spontaneous; it is full of atmosphere and, as he used to like to say, poetry. One of Sutcliffe's greatest strengths was his natural rapport with his chosen subject. He had an ability to put people at ease, and this woman would have had to wait quite a while to enable Sutcliffe to manoeuvre his cumbersome mahogany plate camera and tripod, and to work out the exposure.

The woman is positioned in a doorway, using a frame within the frame for compositional effect. The dark shadows and their graphic shapes also give depth and accentuate the smallness of the subject. The strong line of the shadow leads the eye diagonally up and across to the figure.

The son of an artist (although his mother thought all artists were lunatics), he always used the photographic medium with an artist's sensibility and not just as a recording device. His primary subject was his home town of Whitby, and his many photographs of it provide a wonderful document of the life of the town, but always with a strong emotional or perhaps sentimental element. He stresses the tranquillity and timeless qualities of traditional labours and a settled community – although it could be said that the real subject of this photograph is light and shadow.

FRANK MEADOW SUTCLIFFE
(1853–1941)
Born in the Yorkshire town of Leeds, Sutcliffe's family moved to the fishing town of Whitby in 1870. His father was an artist and art critic and one of the early owners of a camera – a new technology in which he instructed his son. Sutcliffe was encouraged to set up as a commercial photographer and after a brief attempt in Tunbridge Wells, he established his practic e back in the town of Whitby in 1875. As well as studio work, Sutcliffe documented the life of the town and its environs, and its people at work and leisure. It is this remarkable body of work for which he is remembered. He gave up photography in 1922 to become curator of the local Whitby Literary and Philosophical Society, a role he performed until his death in 1941.

recreating the effect

Sutcliffe's choice of viewpoint is all important. The frame within a frame is a useful compositional device; look out for doorways, arches and window frames that you can place your subject within. This photograph also highlights another important compositional point: Sutcliffe uses areas of deep shadow and bright light as building blocks of the picture – don't ignore them because they're not solid objects. The extreme contrast causes metering problems, especially photographing from the dark into bright light. The old advice is to expose for the shadows and develop for the highlights, because if you don't get detail in the shadow on the film or sensor, you can never get it back in the darkroom or even on a computer.

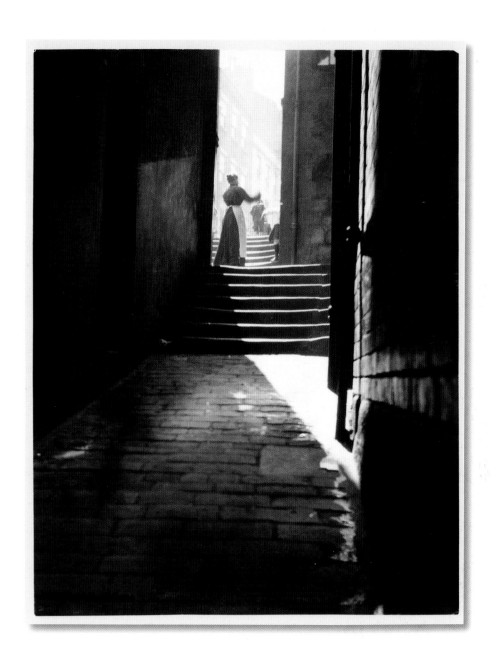

george rodger

Korongo Nuba Wrestlers of Kordofan, South Sudan, 1949 gelatin silver print

behind the image

In this heroic picture of a winning wrestler from Kordofan, South Sudan, George Rodger achieved a significant change in the way Africa and Africans were represented. At the time the prevailing fashion was to show agricultural scenes, semi-naked tribal women or, of course, big game. But Rodger promotes a different sort of Africa – proud and strong, not primitive or poor, but people with their own culture and tradition and an ordered, successful society that stood in particularly stark contrast to Europe at that time, which lay in ruins after the destruction of World War II.

Rodger was understandably greatly disillusioned with Western society having photographed throughout the war, from the London blitz to the liberation of the Bergen-Belsen concentration camp. It must have seemed to him that the Nuba culture, unchanged in centuries and untouched by 'progress', was in fact the superior.

He was first granted permission to photograph with the Nuba in 1949; using Leica and Rolleiflex cameras he spent much time in Africa eventually culminating with his book *Le Village des Noubas* in 1955, an account of his journey through Kordofan in both words and pictures, of which this photograph is the most famous image. Clearly Rodger's ability to gain the trust of the people was key in being able

GEORGE RODGER
(1908–1995)
Rodger was born into a middle-class English family and began taking photographs to illustrate his journals while travelling in the merchant navy. On his return to England in 1936, he was taken on by *The Listener* magazine as a photojournalist. He went on to work for the Black Star agency as well as *Life* magazine and *Picture Post*. He covered the London blitz and the war in Italy, North Africa and France, recording the liberation of the Bergen-Belsen concentration camp and the German surrender. Following the war he became a founder member (along with Robert Capa, Henri Cartier-Bresson and David 'Chim' Seymour) of the Magnum agency and went on to take his most famous photographs of the Nuba tribe in Africa.

to take effective photographs of those who had never come across a camera before. Even so there is perhaps a wariness discernible in the expressions of the men.

Rodger was one of the four founding members of the influential Magnum picture agency. He always kept detailed notes and diaries of his experiences and with stories like that of the Nuba, he was able to provide a 'package' of words and pictures which was particularly appealing to illustrated magazines.

recreating the effect

It would be difficult, if not impossible, to find a tribe now anywhere in the world that has not been photographed, but making a photographic documentary of a community of any kind relies on access. You need to gain the trust of your subjects and be allowed in to photograph the most intimate rituals of their lives, as well as the most commonplace, without intrusion. If you are trying to present reality, capturing the moment and recording events as they happen has to take precedence over the technical considerations of lighting and composition, but in this instance Rodger has managed in very harsh sunlight to get the wrestlers lit from the side, clearly defining the champion's muscularity and heroic status.

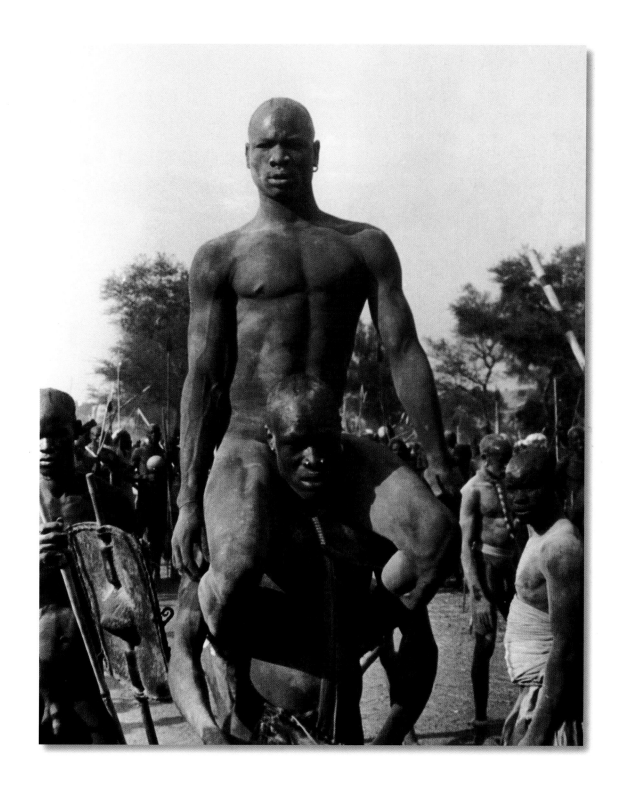

dorothea lange

Migrant Mother, Nipomo, California, 1936 gelatin silver print

behind the image

As a member of Roy Stryker's Farm Security Administration (FSA) photographic unit, Dorothea Lange photographed migrant workers, sharecroppers and the tenant farmers of the Depression mainly in the south and west of the USA between 1935 and 1942. Lange's most famous photograph is commonly known as *Migrant Mother,* taken in 1936 in the pea fields of Nipomo, California near Santa Barbara. The woman and her family had survived by eating peas from the surrounding fields, and birds that her children had caught. She was only 32 but the hard life she had endured in the scorching sun makes her look much older.

Lange, who travelled around in a huge wooden-framed estate car, used a large plate camera to take the photograph – one of a series of six. The unwieldy nature of her equipment makes the intimacy of the portrait an even more remarkable achievement. Lange found the woman and her two children cowering by the side of the road in a crude, badly made tent. She started shooting fairly wide, showing the whole scene of the pitiful family and then got closer and closer as she gained the woman's confidence. The original negative included a distracting thumb in the foreground which Lange insisted on being removed. The picture was published in the *San Francisco News* and led to relief for the camp where the woman lived, as well as many others. The photograph became the symbol for the suffering caused by the

DOROTHEA LANGE
(1895–1965)
Dorothea Lange was born in New Jersey. She gave up teacher training to become a photographer, working part-time in the portrait studio of Arnold Genthe before studying with Clarence H White. She later moved to California, meeting Imogen Cunningham and opening her own portrait studio. In the early 1930s she began to take pictures of people suffering from the effects of the Depression, such as the *White Angel Breadline* in San Francisco in 1933. The following year she met sociologist Paul Taylor whom she was to marry (after divorcing her first husband, the painter Maynard Dixon) and began to work for various Government projects, most notably the Farm Security Administration. After illness interrupted her career for almost ten years from 1945, she travelled extensively around the world with her husband before settling down to photograph things 'close at hand' around her home and family.

recreating the effect

Photographs such as Lange's are not so much about the technical expertise required to capture the images, but the ability to work up close to your subject: to gain their trust to the extent that you can move among them freely and they cease to be conscious of the camera. Photographers today still work in the same way, many spending weeks getting to know the people they hope to photograph. Most would now use digital SLR cameras with fairly short lenses and, if on a professional assignment like Lange, would use a laptop computer to send the often harrowing images back to the picture desks of newspapers and magazines around the world. Outside the world of professional photojournalism though, an in-depth documentary project can be a tremendously rewarding photographic exercise. Getting a picture with the power of Dorothea Lange's requires an empathy and sensitivity to your subjects, which only time and experience can bring.

Depression. A friend of Lange's, Ron Partidge, recalled her methods in the fields of California: 'She would walk through the fields and talk to people asking simple questions – "What are you picking?... How long have you been here?... When did you eat lunch?... I'd like to photograph you," she'd say, and by now it would be, "Sure, why not," and they would pose a little. But she would ignore it, walk around until they forgot her and were back at work, then she would begin to take her pictures.'

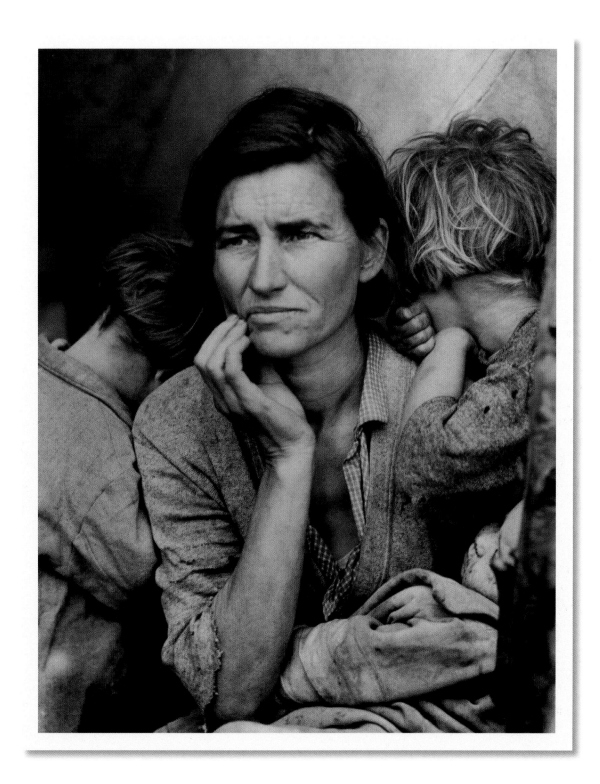

alfred stieglitz

The Steerage, 1907 photogravure

behind the image

One of the key figures in the history of photography, Alfred Stieglitz felt that this was his best photograph. It was taken on board the *Kaiser Wilhelm II* on a transatlantic voyage to Paris when, disillusioned with his fellow passengers in first class, Stieglitz walked to the back of the ship and caught sight of the people travelling steerage. The result, captured on the last sheet of unexposed film he had with him, is very graphic, made up of a series of shapes linked with strong diagonals, with the white boater of a young man on the upper half of the deck at its heart.

ALFRED STIEGLITZ
(1864–1946)

Born in New Jersey, Stieglitz studied in Berlin, returning to the United States in 1890. He edited a series of photography magazines including *Camera Work*, one of the most influential and significant in the history of the medium. A leader of the Photo-Secession movement, promoting photography as a legitimate art form, Stieglitz also did much to promote modern art in general. The founder of the 291 Gallery on Fifth Avenue in New York, he introduced European artists such as Cézanne, Picasso and Braque to the American public as well as promoting American talent such as Charles Demuth and Georgia O'Keefe, whom he married in 1924. The most important of his own works are his portraits of O'Keefe, studies of New York and a series of cloud studies in which he developed the idea of photographic 'equivalents'. He continued to support and promote American artists, opening the Intimate Gallery in 1925 and An American Place, which he ran from 1930 until his death in 1946.

Amazingly, he remembers it was the hat he saw first. 'A round straw hat, the funnel leaning left, the stairway leaning right, the white drawbridge with its railings made of circular chains – white suspenders crossing the back of the man below in steerage. Round shapes of iron machinery, a mast cutting into the sky, making a triangular shape. I stood spellbound for a while, looking and looking. Could I photograph what I felt? I saw shapes related to each other. I saw a picture of shapes and underlying that, the feeling I had about life.'

As well as arranging shapes, Stieglitz makes his point by compressing the space, emphasizing the cramped closeness of the steerage passengers. His treatment of the subject as a formal experiment in composition and a 'straight' rendering of the subject (as opposed to the impressionistic Pictorial style) signalled a crucial departure in the direction of contemporary photography.

The photograph was elevated to masterpiece status four years later, reproduced as a photogravure in *Camera Work*; the 1911 edition was devoted to Stieglitz's new style of photography together with a Cubist drawing by Picasso. It allowed Stieglitz to put his chosen medium on a par with the experimental European painting and sculpture he was importing and exhibiting in his own gallery on Fifth Avenue, New York.

recreating the effect

A modern photojournalist would probably use a 300mm lens on a 35mm camera to achieve the foreshortened perspective of the Stieglitz image. This would allow an even more accentuated two-dimensionality than Stieglitz was able to get with his cumbersome equipment. It is the different levels and angles of the ship's architecture that allow Stieglitz to stack up elements in the composition using the compositional blocks like a Cubist painter. To find a similar scene one might look for staircases or bridges where you can find geometric shapes with animation at various levels which can then be drawn together using a telephoto lens.

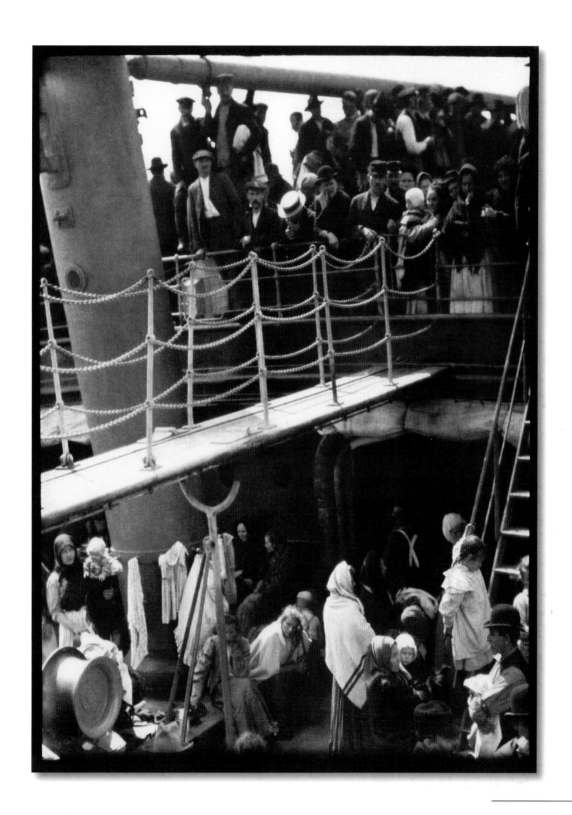

don mccullin

Refugees from East Pakistan on the Indian Border, 1971 gelatin silver print

behind the image

A compelling portrait of a desperate mother and child, this picture nearly didn't happen at all. McCullin had had to argue long and hard to persuade *The Sunday Times* picture desk to send him to cover the Pakistan-India war in 1971. The monsoon rains were due and McCullin had read that a million refugees were fleeing the war and crossing the border into India. A million turned out to be an underestimate: 'the road was an endless flow of people; people carrying the crippled; the crippled carrying the crippled.' He knew that flooding from the rains would mean the risk of cholera and other diseases and when he got there he discovered great distress and dead bodies everywhere. 'Often I found myself not wanting to look at what I had come to photograph. Emotionally I was drained. I thought of my pictures as atrocity pictures. They were not of war but of the dreadful plight of the victims of war.'

The picture was taken in a moment: McCullin just saw the two faces and went in and took the photograph, with no conversation and no real contact. 'I don't suppose this child had ever seen a white face before,' he says, 'but she was in distress long before she saw me. The child was very hungry, she was starving'. The picture concentrates on emotion: the anguish of the child, the appeal of the mother. And perhaps part of its power is

that it is reminiscent of Madonna and Child images, so familiar in the history of Western art.

The wet conditions were also bad for photography, the rain causing chaos with his cameras. 'With Nikon Fs you had to take the backs off completely and the films could be ruined and the cameras waterlogged and unusable.' He took this picture with a 135mm lens on a Nikon 35mm camera. McCullin routinely carried two Nikon F cameras, three lenses and 20 rolls of Kodak Tri-X film. This was a time before light meters were built into cameras and to be on the safe side he carried two meters. He used the 135mm lens, the longest of the three he had with him, to get closer and crop in tight on the faces.

DON MCCULLIN
(1935–)
Born in North London, McCullin was called up for National Service at the age of 18 and served with the Royal Air Force. He developed an interest in photography and in 1958 photographed some of his friends in a burnt-out building. When some members of this 'street gang' became suspects in a murder investigation, McCullin was able to sell the pictures to *The Observer* newspaper. McCullin subsequently got offers of work from other papers and bought himself a 35mm Pentax SLR camera. Throughout the 1960s and 70s he established himself as one of the world's leading photojournalists, covering war and disasters around the world from Vietnam and Lebanon to Cyprus and Northern Ireland; in Britain he focused on the poor and unemployed. More recently he has been documenting the impact of HIV and AIDS in Africa.

recreating the effect

Cameras have not changed that much in the last 30 years and the methods of taking an image like this would be roughly the same. A film or digital SLR camera with a medium telephoto lens is sufficient to get the powerful tightly framed composition. The great difference for news photographers today is how the images are dealt with after the shutter is pressed. McCullin's pictures printed in *The Sunday Times* would often be the first images of the event available. He did not have to compete with live television feeds from important events, a great problem for newspapers today. The 2004 Tsunami tragedy, for example, presented photographers with similar scenes of despair and devastation. McCullin's film would have taken over a week to get back to London while the pictures in 2004 were taken on digital cameras and transmitted minutes after they were taken. Nevertheless, by the time they appeared in print the following morning, the images were already familiar from 24-hour television news.

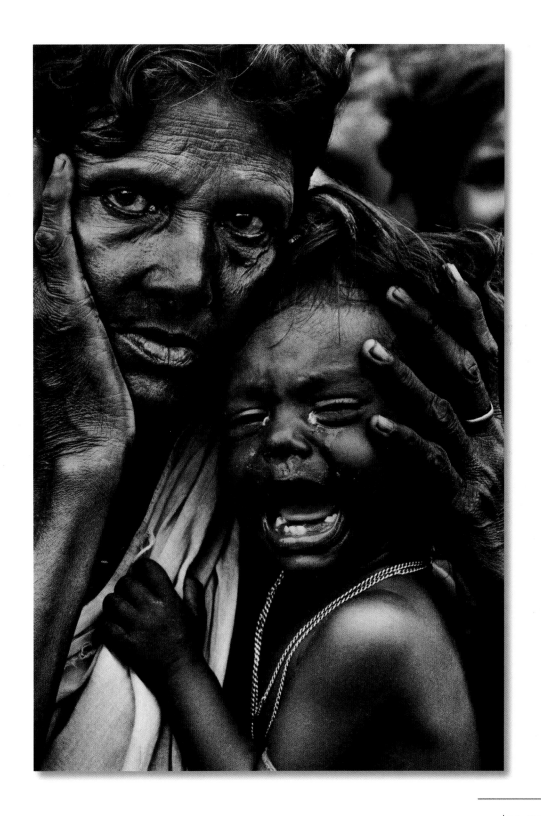

horace nicholls

Derby Grandstand, *c.* 1909 gelatin silver print

behind the image

A striking picture of a packed grandstand on Derby Day, this is one of a series of images Nicholls made of British society sporting events in the so-called 'season'. It was at its peak during the Edwardian period, including events like Royal Ascot and the Henley Regatta, and his photographs define the excitement and elegance that prevailed at that time. Cecil Beaton is known to have used Nicholls' photographs when working on his designs for the famous Ascot sequence in the film *My Fair Lady.*

Nicholls wanted to convey as much of

HORACE NICHOLLS
(1867–1941)
Nicholls was born in Cambridge in 1867 but moved to the Isle of Wight as a child when his artist father became interested in photography and opened a studio there. At the age of 14 he worked for his father and then in 1884 he left home to become apprentice to a chemist in Huddersfield. A keen traveller, Nicholls left Britain for Johannesburg in 1892 and set up as a photographer. When the Boer War broke out in 1899, he was invited to become the official photographer for the London-based periodical *South Africa*. Returning to Britain he established himself as a freelance photojournalist and notably photographed the social and sporting events of the Edwardian era. He was employed by the Department of Information during World War I, after which he photographed much less, devoting more time to his family. He died of diabetes in 1941.

the highly charged atmosphere as he could with these big scene-setting pictures. In this case he has compressed the space in the frame to accentuate the size of the crowd. The grandstand and the crowds seem to pile up on each other and fill the entire frame. He has allowed only a sliver of sky at the top of the picture and a little of the racetrack at the bottom, giving us the feeling that the enormous grandstand is bursting at the seams in anticipation of the race.

One of the first photographers to make a living from documentary photography, Nicholls would sell his pictures to the illustrated press such as *Tatler* and *The Illustrated London News*. He was determined to make his pictures pay; if he didn't get what he wanted in the camera he was not beyond inventing it in the darkroom and would splice together parts of different negatives to get an exciting scene that he knew he could sell to the press. As he explained in a 1934 article for Kodak: 'Sometimes when you have made a series of negatives of one subject, there will be found among them views which have little interest when seen separately, but which if carefully assembled, by using a portion of one and a portion of another, can be made to produce a striking result.'

recreating the effect

The way Nicholls has flattened the perspective, giving the impression of the crowds piling up on themselves, is all important and today we would use a long lens to achieve the same result. His framing is also crucial – filling the whole picture space with his subject. To have placed the top of the stand half way up the frame, allowing acres of sky would give a very different impression. Sporting events are very rich sources of good pictures even if you're not pointing your camera at the event itself. The accredited press photographers are in the best position to photograph the actual sport, but turning your camera on the crowd, or taking pictures from within grandstands can sometimes capture the atmosphere much better. One of the best pictures I took while photographing a year in the life of Bradford City Football Club in 1988 was under these circumstances: I knelt on a crash barrier at the back of the stand to get some extra height and got a great picture of the fans celebrating a goal. At another match I spent the whole game with my back to the play photographing the crowd.

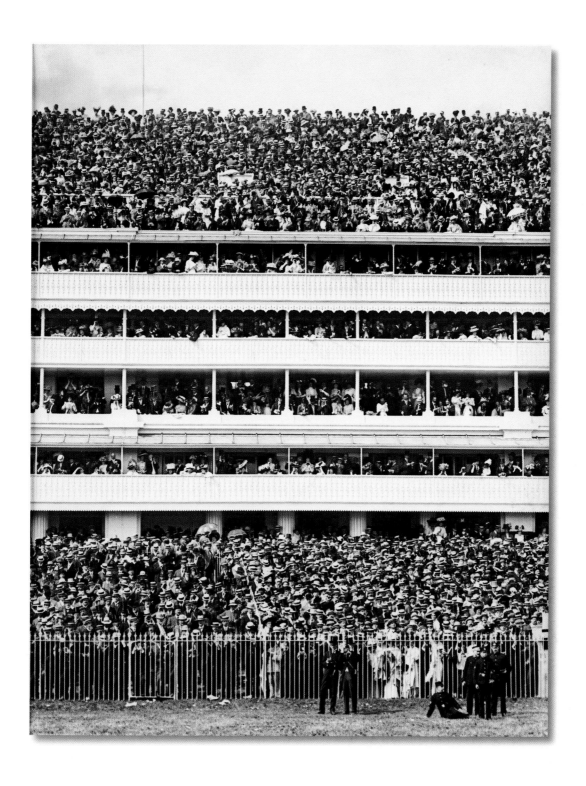

larry burrows

South of the DMZ, South Vietnam, 1966 c-type print

behind the image

A wounded marine seems to reach out to a stricken comrade during the fighting for Hills 400 and 484 during the Vietnam War. This is one of Larry Burrows' most famous images from the conflict with which he is most associated, taken in South Vietnam in 1966 near Don Ha.

A technically brilliant photographer, Burrows had begun his career as a darkroom assistant and, working his way up in the profession, he honed his sense of composition by photographing old master paintings and other works of art. This interest seems particularly relevant here. The wounded soldier with his legs held together by bandages lying against a tree stump or wooden stake, his arms outstretched and holding on to another stump, is reminiscent of a crucifixion. The whole scene on top of the hill puts us in mind of familiar images in the history of art depicting Christ at Calvary or the descent from the cross, where Christ is taken down from the cross after death.

The black soldier, with his own head bandaged, appears to be reaching out in a gesture of aid towards the fallen man. It is this apparent relationship and the compassion that makes the picture so powerful, but photographers who worked alongside Burrows in Vietnam say that the black soldier was not reaching out in sympathy but staggering around aimlessly and stumbled straight past the stricken man, just glad to be able to sit down on the ridge. Using a short lens on his 35mm camera Burrows gets so close, you feel as though you are in the middle of this almost biblical tableau of horror. The lens exaggerates the perspective and also accentuates the gesture of the outstretched arm.

Photographing for *Life* magazine at that time made him one of the most important and respected photojournalists, the star of his profession. He loved the magazine and was so keen to get his pictures on the cover that he even blocked off a small tab at the top left of his viewfinder where the *Life* logo would go. He would have shot many pictures upright with this in mind.

recreating the effect

War photography always seems like a romantic and exciting occupation, but it is a very dangerous business, never more so than with today's high-tech weapons. The role of the war photographer has also diminished with the proliferation of television and round-the-clock news media. The days of making your name in this field like Burrows, Robert Capa and Don McCullin are now long gone, and let's not forget that two of that trio died in its pursuit. Inevitably though, photographers are drawn to where the action is. Shooting with wide-angle lenses will squeeze a lot into the frame and gives dramatic perspectives but you have to get in close. Burrows was able to do this by becoming accepted by the soldiers and working alongside them – they, in turn, hoped his pictures would get the war stopped when they were shown in *Life* magazine.

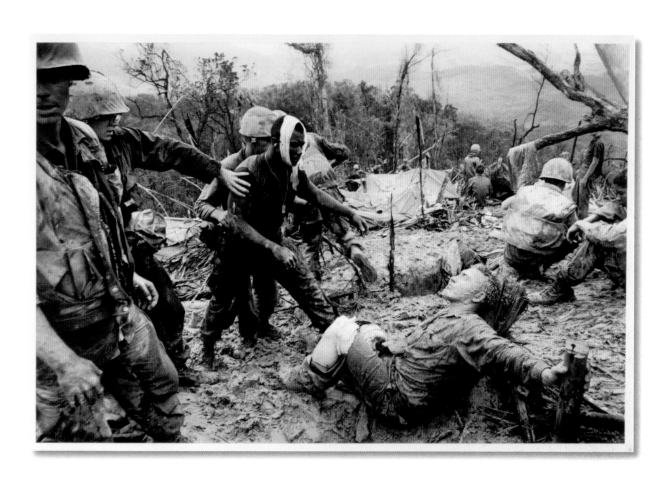

thomas annan

Close No. 28, Saltmarket, 1868 carbon print

behind the image

The narrow shaft of light illuminating this alleyway accentuates the feeling of the buildings closing in on the street. And despite the obvious squalor of their environment, the dishevelled inhabitants pose for the camera or look on almost proudly. This photograph is part of a series taken by Thomas Annan and published under the title *Old Closes and Streets of Glasgow*. They were the result of a commission in 1868 from the Glasgow City Improvement Trust who wanted to make a record of areas that were due to be demolished to make way for improved housing. Annan was among the very first to set up as a commercial photographer, initially using Fox Talbot's patented calotype process. By the time of this project he was using the superior wet collodion process and converted a Hansom cab to a mobile darkroom so he could develop his wet plates on location.

When Annan was commissioned to take these photographs, they were not meant to be campaigning or political. They were intended simply to record something that was soon to disappear, but in fact they were to have a profound influence on the development of documentary photography as a means of demonstrating the plight of the poor and underprivileged, thereby illiciting support for relief programmes and political reform.

The alleyways were known as 'closes' in this part of the city and Annan deliberately concentrated on the streets that had open sewers running through them, typifying the dark, damp and fetid atmosphere which was characteristic of the slum housing. Long exposure times were necessary and many of the views are therefore eerily devoid of any human presence for a location which is defined by its overpopulation.

In this view, the group in the close have kept still for the camera but the man on the balcony in the upper left of the picture has obviously moved during the exposure leaving his ghost to lean against the wall.

THOMAS ANNAN
(1821–1887)
Annan trained as an engraver but after acquiring the patent rights to Fox Talbot's calotype process, he set up a photographic studio in Glasgow in 1857. He worked on architectural studies and later portraits and is particularly remembered for his photographs of prominent Scots of the day such as David Livingstone. In 1866 Annan was commissioned by the Glasgow City Improvement Trust to photograph slum areas of the city which were due to be cleared, resulting in *Old Closes and Streets of Glasgow*. He also undertook a number of other Glasgow-based projects including the building of the Loch Katrine Waterworks, 1859–1877, the Munich painted windows in Glasgow Cathedral, 1867 and the series *Old Country Houses of the Old Glasgow Gentry*, 1870. He passed on his business to his sons John and James Craig Annan; the latter also became a celebrated photographer.

recreating the effect

Documenting everyday living conditions or unremarkable buildings may seem a mundane subject, but time passes quickly and once a generation has gone, the everyday can become intensely interesting for its nostalgic and historical value. It is entirely possible that your photographs of a view, a turn in the road, a building or a local event might be or become the only record in existence and become valuable as a consequence. Something you know will be demolished or redeveloped is worth photographing but often the most fascinating aspects of archive photographs are the very things that are likely to be overlooked at the time – the details of everyday life: road and shop signs, advertising, the clothes people wear, cars and buses. Don't try to edit out these details in favour of a prettier composition. They are what capture the atmosphere of the age and provide fascination for future generations.

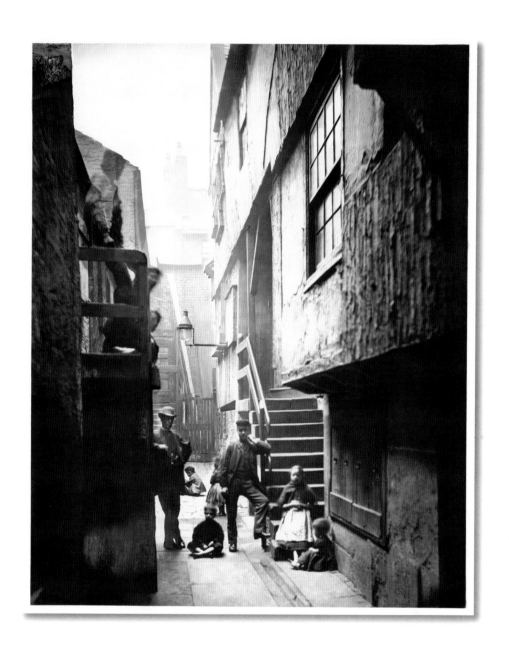

lewis hine

Man in a Firebox, *c.*1925 gelatin silver print

behind the image

In this image, Hine uses the massive hatch of the firebox to frame the worker; it looks as if the machine might swallow him, or perhaps that he is an integral part of it. This composition, with a worker framed by a large circular industrial element, is common in Hine's work from the 1920s. It is not a naturalistic representation of a man at work, but rather a posed image so as to create an archetype – the man with the hammer will have been asked to hold the pose and looks a little self-conscious as a result.

Hine was a campaigning photographer who began by documenting immigrants arriving at Ellis Island in New York. One of the reasons for the strong documentary tradition in the United States was the influx of immigrants in the late 19th and early 20th century; it caused rapid urban growth and as a consequence the explosion of appalling slum housing. Hine was passionately interested in the plight of the downtrodden and, using a 5×7in camera, photographed immigrants, child labourers and manual workers, promoting his photography as a means to bring about political reforms.

Not a great technician, he had a straightforward way of working, often using simple compositions with his subject in the centre of the image, framed by their environment. In 1920 he graduated to a 4×5in Graflex camera with a moderate wide-angle lens to shoot his series *Work Portraits* and his photographs became increasingly more stylized and less critical. He made a number of portraits of workers

LEWIS HINE
(1874–1940)
Born in Wisconsin, Hine studied sociology and remained committed to social reform throughout his life. In 1904 he photographed immigrants arriving at Ellis Island in New York, drawing attention to their treatment and subsequent living conditions. After joining the National Child Labor Committee in 1908 he documented the use of children in American industry, using his work to help lobby to end the practice. He also worked for *The Survey*, a leading social reform magazine, and in 1908 photographed the steel industry in Pittsburgh for the *Pittsburgh Survey*. During World War I he documented American Red Cross work in Europe but returned to industry in the 1920s and 30s, concentrating on those who made up the workforce, as can be seen in his celebrated series on the construction of the Empire State Building.

compositionally similar to this one, not necessarily documenting a real job in the factory but rather using industrial elements – gears, cogs and turbines – as visual devices in which man is made to fit. During the 1920s he worked for commercial clients who were using these images for promotional purposes so his imagery became less about documenting harsh conditions and more of a romantic view of the worker and his place in the industrial age.

recreating the effect

Getting permission to photograph in factories can be difficult but taking more general photographs of people at work affords many opportunities for interesting pictures – you just need to look at Sebastião Salgado and his 'workers' series and Robert Doisneau's wonderful Renault factory workers. The massive hulking steel shapes of factories and shipyards make dramatic backdrops, but you can apply Hine's techniques to a wide range of subjects, even people working in markets or shops. The goal is to make a composition that combines the person with their occupation in such a way that it represents the nature of their work as a whole and their place within it, and is not just an illustration of someone at work.

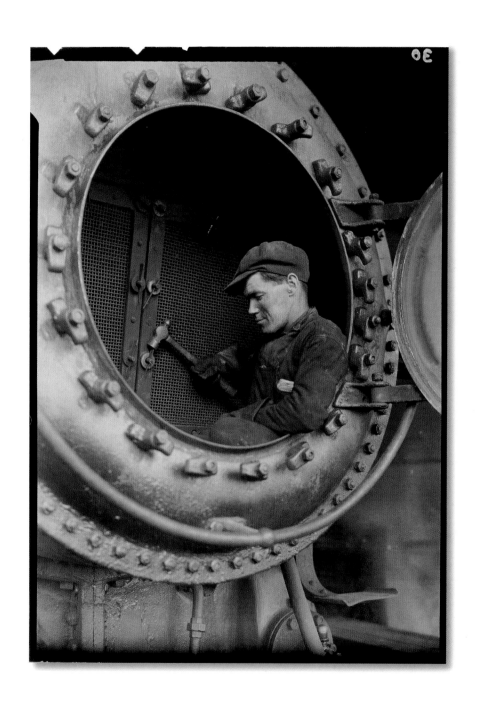

robert capa

Women in Bilbao run for safety with rebel planes approaching, 1937 gelatin silver print

behind the image

One of the first to use the new portable 35mm cameras and faster films to get close to the action, Capa was famous for saying 'if your pictures aren't good enough, then you aren't close enough.' And here Capa is right in thick of the action as people run for cover during an air raid in the streets of Bilbao, Spain.

Taken in May 1937 during the Spanish Civil War, Fascist troops were closing in on the town, resulting in a battle and a Loyalist victory. There's high drama, reality and immediacy, all the elements of a great news picture – although it is a little strange that nobody in the background looks particularly worried. This might be explained by the fact that the sirens sounded so regularly for air raids – according to Capa up to 20 times in a morning at that time – that some of the urgency went out of the alarm. People would sit and wait outside the shelters rather than rush from their homes every few minutes.

Compositionally, the photograph is dynamic, with the running figures and tramlines accentuating the perspective and the car behind giving a feeling of a chase. To a good photographer these things come together in an instant, even in a moment of panic like this.

In 1939 *Picture Post* magazine named Capa 'the greatest war photographer in the world', a title that he earned with his coverage of the Spanish Civil War. As a struggling Hungarian photographer in Paris in the early 1930s he had invented the idea of 'Robert Capa', a successful American photographer, and with his girlfriend Gerda Taro, promoted the myth to help sell his pictures. Taro was tragically killed in Spain but Capa continued to live up to his own hype, not least with his incredible images of the D-Day landings which he photographed in the surf with the first wave of troops. Tragically many of these pictures were lost when the films were processed in *Life* magazine's London office; they were hung in a drying cabinet in the usual way, but the heat was turned up too high and the films began to melt. Out of 72 exposures (two rolls) only 10 were saved!

ROBERT CAPA
(1913–1954)
Suspected of Communist sympathies, Endre Friedmann was exiled by the secret police from his native Hungary at the age of 17. It was in Paris that he began working as a photojournalist in the guise of the invented character 'Robert Capa', a successful American photographer. Covering the Spanish Civil War and then World War II, he established his reputation as the world's leading war photographer revolutionizing reportage photography by using a small 35mm Leica, which allowed him to get close to the action and capture dynamic and intimate pictures.

A glamorous and charming figure, Capa had an affair with Ingrid Bergman shortly after the war and flirted with acting and directing in Hollywood before leaving to establish the Magnum photo agency with fellow photographers Henri Cartier-Bresson, David 'Chim' Seymour and George Rodger.

recreating the effect

To be an effective photojournalist, it is vital to know and understand what is going on, before even thinking about taking pictures. Photojournalists need to familiarize themselves with a story before they get anywhere near the trouble zone. Getting close to the action is obviously extremely dangerous but if you do find yourself in a situation like this or want to use a reportage style like Capa, a short 50mm or 35mm lens on a 35mm camera would accentuate the dynamic perspective for such a shot. To freeze movement of people running towards you, a shutter speed of 1/250 second should hold them. With modern equipment you can use autofocus, but be careful in this sort of situation – it would be easy for the autofocus to settle on the car behind rather than the running women.

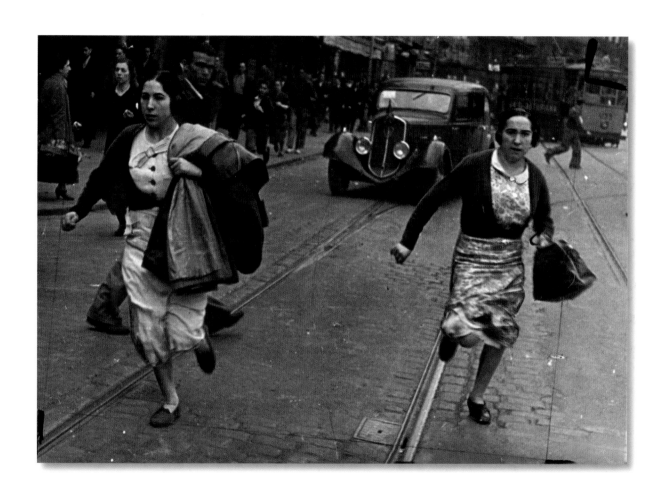

john thomson

Covent Garden Labourers, 1877 woodburytype

behind the image

This image of labourers in Covent Garden's flower market was included in Thomson's famous book *Street Life in London* – a ground-breaking exercise showing real London street types and revealing to the public the extent of their poverty.

By 1872 Thomson had already travelled in the Far East for ten years and produced a remarkably sensitive record of Chinese life at the time, showing life on the streets and portraits of the people there. On his return, alongside the writer Adolphe Smith, he wanted to record what he thought to be the true London. His was a city inhabited by an assortment of Gypsies, cabmen, flower girls, conmen, street vendors and pitiful beggars.

The book was published in 12 monthly parts with woodburytypes from Thomson's negatives (a method of transferring the image to a lead plate so that it can be printed mechanically). Thomson used the time-consuming wet collodion process and this image demonstrates that, although he is aiming at a naturalistic portrayal, the scene is highly staged. He has assembled a cast of characters who in their various poses with their different props represent their trade and the individual jobs they do at the market.

The picture is taken from mid distance with full sunlight streaming in from the side; the aperture would have been wide open – the shot needed to be as quick as possible and it would be hard to keep a large group still for long. Taken early in the morning, the market would have been full of noise and bustle. The subjects are very aware of the camera and a bit self-conscious – the men with the baskets look slightly frozen and the two men in the middle seem to have been asked to look at the camera and hold the pose for a few minutes.

As well as grouping the characters, Thomson has carefully set up the composition, with buildings adhering to right angles in the picture space so the whole composition achieves balance and harmony. It almost has a theatrical quality, like a stage set.

JOHN THOMSON
(1837–1921)
Born in Edinburgh, Thomson was apprentice to a maker of optical instruments before moving to the Far East to join his brother in 1862. He spent ten years there, setting up a portrait studio in Singapore and notably making an expedition to Cambodia, becoming the first person to photograph the ancient city of Angkor. After returning to Britain to publish his pictures he spent a further five years in China. His photographs were published in *The Antiquities of Cambodia*, *Illustrations of China and its People* and *The Straits of Malacca, Indo China and China*. Returning to London he turned his attention to the condition of the poor in the city and in 1877 he produced *Street Life in London*, one of the first social-documentary photography projects.

recreating the effect

With the mobility of modern cameras and the film speeds available today it would now be possible to take far more natural shots of the same subject, to take 'candid' pictures of people while they work. However, by deliberately employing Thomson's method of carefully constructing a set with your characters, props and buildings, you could perhaps achieve a more iconic or universal representation of your subject. Markets are still good places to take photographs, as people working in them are often flamboyant and like to be photographed; the real problem these days is getting people to ignore you. They often play up to the camera and lark about especially when they're in groups. You would have to spend some time, as Thomson did, building up the confidence of the people you want to photograph. Spend enough time in the background and eventually they will forget you are there.

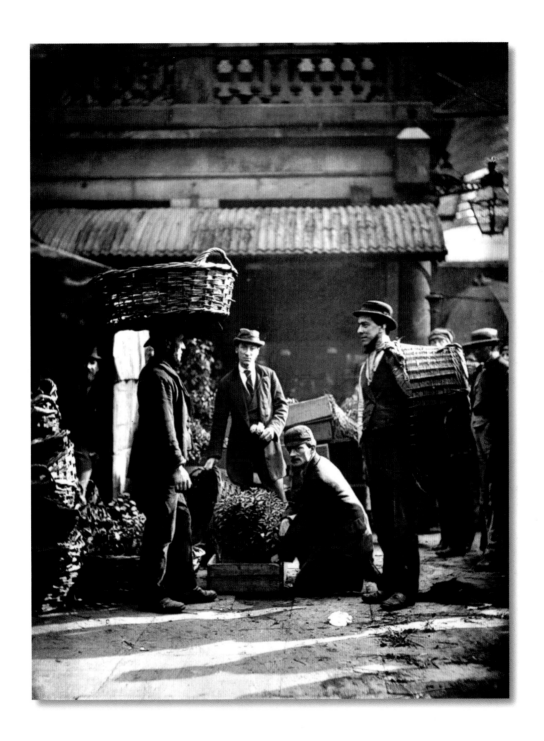

bert hardy

Gorbals Boys, 1948 gelatin silver print

behind the image

This picture is from a set that Bert Hardy shot for *Picture Post* magazine in 1948. He had been sent to do an essay on the Glasgow Gorbals to supplement a set of photographs by the legendary Bill Brandt, who had decided to concentrate solely on the buildings.

This particular image is one of Bert Hardy's most famous photographs, but the irony is that it was never actually printed with the story in the magazine as it didn't fit the shape of the layout! Later in his career though, Hardy was always being asked to write articles for photography magazines and this is the picture he invariably sent out to accompany his words. It was published so many times it became famous and has appeared on many book covers.

The dynamism of the picture is in the composition, with the line of the pavement accentuating the perspective, and the boys placed on the kerb line giving the picture real pace. The picture was made very quickly and Hardy took only one frame. Surprisingly he never exchanged a word with the two boys, which was rare for Hardy, who was well known in the press community of London's Fleet Street for his chirpy personality and ability to get on with anybody.

Hardy was one of the first on Fleet Street to use the highly portable 35mm Leica and probably took this photo with

BERT HARDY
(1913–1995)
Self-taught and from a working class background, Bert Hardy worked initially as a darkroom assistant and printer for the General Photographic Agency, but he founded his own firm, Criterion, early in his career. This was in turn absorbed by *Picture Post* magazine, the leading British picture publication of the day; he began to take photographs for them in the early 1940s and it was on *Picture Post* he was to make his name. He photographed the London blitz and then, called up by the Royal Army Photographic Unit, took part in the D-Day landings and the liberation of Paris. He was among the first photographers to document the liberation of the Nazi concentration camps. Returning to documentary stories for *Picture Post* after the war, he later went on to become a successful advertising photographer in the 1960s.

a standard lens. The low available light adds to the mood, and the obvious personality of the boys shows an empathy with the scruffy children which was typical of Hardy. He himself had grown up in poverty in the East End of London. His wife Sheila Hardy, who worked as a researcher at *Picture Post* noted that, 'He always kept close to his roots. It's what made him as a photographer. He could relate to anyone.'

recreating the effect

The obvious difference between photographing street scenes today and in 1948 is that there were so few cars then. The relatively empty streets created a greater impression of space. Today there is so much 'street furniture' to spoil the shot: signs, lights, railings and cars wherever you look that make streets rather less photogenic than in Hardy's day. It's worth working early in the morning before streets get too congested or late at night. Photographing children is also difficult now as parents and teachers or even passers-by want to know what the photographs are to be used for. As ever with documentary photography it's invaluable to get to know your subjects and spend some time in an area to gain people's confidence. You might find it rewarding to try to emulate what was Hardy's great skill – to cover an event and edit the pictures down, encapsulating the whole story in the six or seven pictures that a magazine would require. Remember always to get an establishing picture, and try to sum up the complete story in one frame for use as a cover picture or double-page spread.

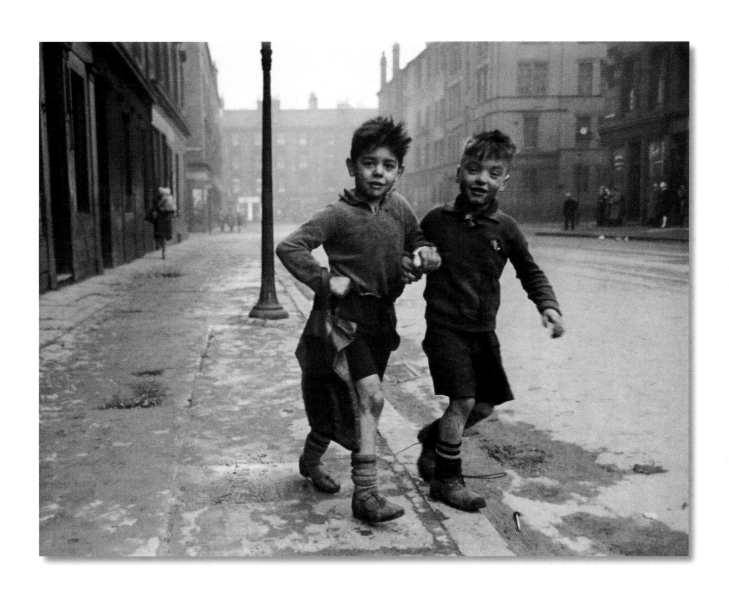

tony ray-jones

Glyndebourne, 1967 gelatin silver print

behind the image

This is English eccentricity at its best. Why are these well-to-do people (they can be identified as affluent by their clothes and the fact that they're drinking wine in the middle of the day) sitting in a field with a herd of cows? Many people would find the fact that this couple are in evening dress sitting at a picnic table in a field absurd, and Jones has exaggerated the joke by making it appear that they are almost amongst the cows. What we can't see in the photograph though is the boundary ditch keeping the cows off the lawn.

Although he died tragically early, Tony Ray-Jones is one of the most influential of the British post-war photojournalists. This, one of his most famous images, is part of his series on the British at leisure. The setting is the Glyndebourne Opera House, set in the Sussex countryside and one of the social events of the English summer. Part of the ritual of attending performances is to take a picnic to eat on the lawn beforehand, which is clearly what this couple has done, with great planning and preparation.

recreating the effect

Although the opera house has been refurbished, Glyndebourne hasn't changed since the 1960s and picnickers in evening dress are still to be found during the summer season every year. When you're trying to get good pictures at events like this the trick is to melt into the background; try to dress like the guests around you so as not to draw attention to yourself as an outsider. It makes sense to use a telephoto lens so you can shoot from a distance and not be observed, though many people at these events feel on show anyway and actually like to be photographed.

The power of this photograph is the clever juxtaposition of two seemingly incongruous subjects – things that do not belong together. Unlikely combinations are a rich source of photographic potential. Manipulate the position of elements within your frame, either simply for humour or to draw the viewer into the image; make them look harder and search for meaning in what you have chosen to show.

The two incongruous elements of the cows and the couple have been pulled closer together by using a medium telephoto lens which compresses the perspective. The isolation of the couple, in the middle of the cows but also in their own protected world, makes them look oblivious to their surroundings (and in fact to each other), and also references the invisible barriers of the British class system, more rigid in the 1960s than today, and defined by events such as Glyndebourne, which tends to be frequented by the wealthy and privileged.

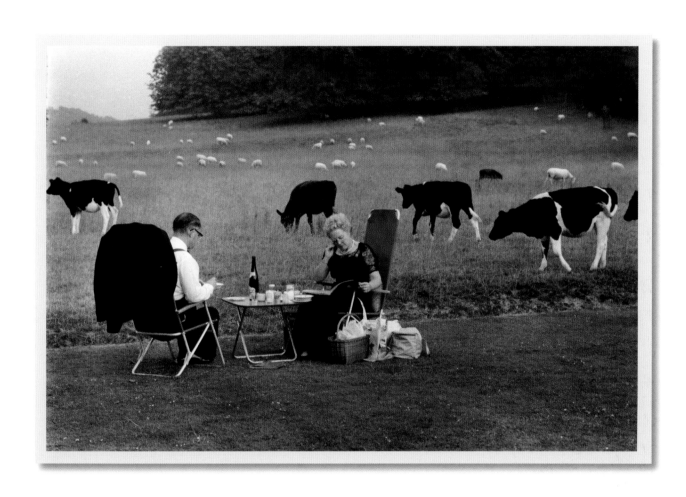

william henry fox talbot

The Open Door, 1844 salt print from calotype negative

behind the image

This simple picture of a doorway with a broom leaning against the wall is one of the most famous images in the history of photography, principally because it is one of the first. It is nevertheless a powerful image which intrigues and rewards closer inspection. Who does the broom belong to? Where have they gone? The interior at first looks like impenetrably dense shadow but actually a window is visible at the back of the room, showing fine detail in Talbot's primitive print.

It was frustration at his own inability to draw that made him experiment with a mechanical device to retain an image. Talbot attempted to draw with the aid of a *camera obscura* (a simple darkroom or box into which an image can be projected by a lens), and it was while in Italy that he came up with the notion of 'how charming it would be if it was possible to cause these natural images to imprint themselves durably and remain fixed on the paper.' He experimented with a portable *camera obscura,* realizing that the smaller it was, the more quickly the image would be attained, and accordingly had several small boxes made with fixed lenses of shorter focus, and obtained 'very perfect, but extremely small pictures.' These little boxes measuring two or three inches were nicknamed 'mousetraps' by Talbot's family who frequently encountered them around the family home.

Talbot's method of fixing the image he called the calotype; it produced a paper negative from which multiple prints could then be made. He produced his 'salt-paper prints' by coating paper with an emulsion of light-sensitive salts, which was

> **WILLIAM HENRY FOX TALBOT**
> **(1800–1877)**
> Born into a semi-aristocratic family at Lacock Abbey, Wiltshire, Talbot attended Harrow School and became a distinguished scholar at Trinity College Cambridge. In 1832 he became a Fellow of the Royal Society and served as a Member of Parliament from 1833 to 1834. He began work on trying to fix an image on to paper when he became frustrated by his artistic abilities on a trip to Italy in 1833. In 1840 he patented his calotype process using a *camera obscura* to obtain a negative from which any number of positive prints could be made, and thus laid the foundation for modern photography. In 1843 he founded a printing house for the production of photographic prints and in the same year published the first photographically illustrated book, *The Pencil of Nature*. In later years he turned to other interests, contributing to the decipherment of Assyrian cuneiform inscriptions.

in turn sensitized with silver nitrate and left in contact with the negative on a printing frame in sunlight for as long as it took for an image to form. Then the paper was washed and the image fixed.

Talbot was amazed by the detail that photography was able to capture, marvelling at how even the most complex subjects such as multi-faceted windows, leaves on a tree or the bristles of this broom, however insignificant or peripheral, were reproduced exactly. Photography did not simplify, suggest or edit, nor did the 'pencil of nature' – as his book was called – ever tire.

recreating the effect

The modern photographer has no worries about creating the image in the first place but there are valuable lessons in what Talbot is showing us: unlike the painter who chooses what to include, the camera shows minute and superfluous detail whether you like it or not, so always be aware of what is in your viewfinder and whether you want it to be there in the final photograph. Also the simplicity of his composition but the strongly symbolic feel is a lesson well worth learning. The broom and the open door clearly allude to a human presence that is absent from the picture; this is a powerful trick that can be applied to many situations – a glass left on a table or an open book, perhaps. Only enthusiasts would attempt to replicate Talbot's processes, but with sepia or gold toning in the darkroom or using the tools in Photoshop, you could obtain vintage colour effects.

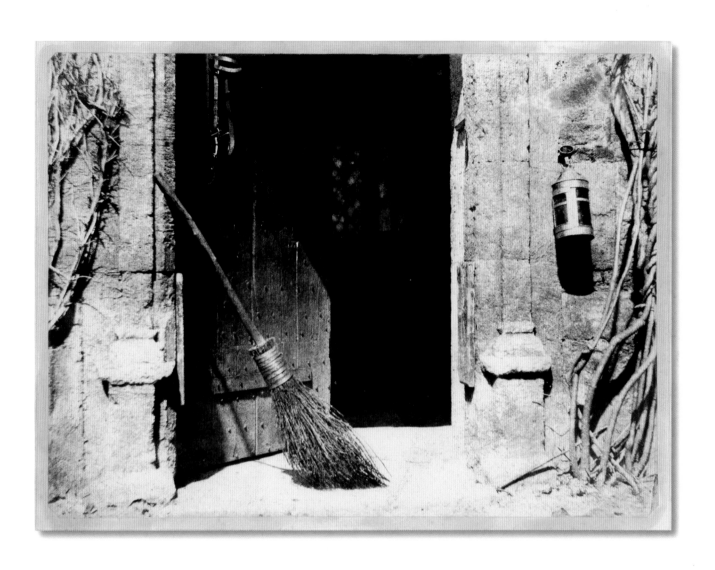

josef koudelka

Gypsies, *c.* 1970 gelatin silver print

behind the image

This is a very structured photograph which perhaps reflects Koudelka's previous theatrical work back home in Czechoslovakia – he was the official photographer of the Za Branou Theatre in the late 1960s. Koudelka originally studied aeronautical engineering and perhaps this training also influenced his sense of ordered shape and form.

This picture breaks many rules of photography, shooting against a bright window light, leaving the figure on the right in heavy shadow, but the light gives it great drama and the brave framing further focuses the composition. He has used the walls and doorway to frame the subject with the dark doorway emphasizing the back-lit figures.

Koudelka has made a life-long study of Gypsies, initially in his native Czechoslovakia and, after he was able to leave Prague, in Spain, Ireland, Portugal and Greece. He has charted their way of life, rituals and especially their musical performances. The hats worn by this trio might suggest that they are showmen of some sort. In fact the drama of the picture makes one think of a rock band – at first glance the man on the right even looks as if he's leaning on a piano.

The mood of the photograph is one of defiance. This is a culture in decline and the way Koudelka has boxed them into the dark space has made them look penned in or trapped. But still they gaze out with self-confidence – challenging the viewer.

Koudelka used just the natural light from behind, casting a deep shadow around his frame in the foreground, and probably darkened down the edges of the print in the darkroom to throw extra emphasis on the illuminated stage.

JOSEF KOUDELKA
(1938–)
Koudelka was born in Boskovice, Moravia (Czechoslovakia). He studied aeronautical engineering in Prague and worked as an engineer from 1961 to 1967. At the same time, he worked as freelance photographer, specializing in theatre photography and beginning his life-long project photographing Gypsies. In 1968 he turned his camera on to the Russian invasion of his country. His pictures of this, which could not be published in Czechoslovakia, found their way to New York via museum director Anna Fárová. Championed by the Magnum agency his photographs were published in the West and the Czech Minister of Culture was persuaded to let Koudelka leave the country to continue his work documenting Gypsy life. Joining Magnum in 1971 he moved to Paris and worked closely with Henri Cartier-Bresson, and only returned to his homeland in 1990, after the break-up of Communism.

recreating the effect

With a tricky lighting situation such as this I would concentrate on getting the exposure right on the faces, taking a meter reading of the central figure's face in particular and exposing for that. Of course you could recreate this sort of lighting in the studio, which would not be hard to do with one strong light from behind the window, and you could throw additional light back on the characters' faces with extra lights or reflectors. The dark walls and doorway framing the group are what makes the picture, and this is a compositional device that can be readily applied to many situations; doorways and windows are obvious choices to use to frame your subject but the introduction of almost any foreground element such as a tree branch or pillar can do the job of focusing attention on your subject. If you are shooting into the light like this your frame is likely to be in deep shadow, but it can always be further darkened in the darkroom or using Photoshop to help push the eye in towards the subject.

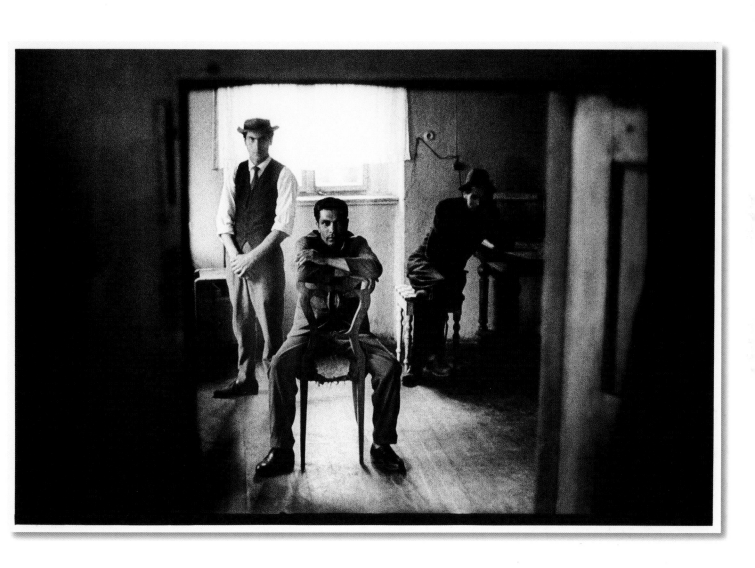

eadweard muybridge

Dusel hauling a heavy weight (from *Animal Locomotion*), 1884–5 collotype print

behind the image

The greatness of this photograph, one of many that Muybridge made documenting the movement of people and animals, is in the influence it had on the world of art. Images like this one have become iconic in photography and Muybridge is a major figure as a result. Published in his book *Animal Locomotion*, they captured the way birds, animals and people moved and in particular were a revelation for artists – the convention of painting galloping horses with at least one hoof on the ground at any one time was shattered. Muybridge's development of high-speed cameras was also a crucial step towards the development of the moving image; Thomas Edison absorbed these new discoveries and went on to introduce cinematography in the 1890s.

Having made his name with many notable stereoscopic views and later panoramas, including an important series on San Francisco, Muybridge was approached by Leland Stanford, the president of the Central Pacific Railroad, to attempt to photograph a horse moving at speed. He wanted to settle a long-standing controversy as to whether a trotting horse had all four hooves off the ground at any point. Muybridge started by photographing a horse called Occident, but without any great success as the wet collodion process normally required several seconds of exposure for good results. In April 1873 he managed some better results in which a recognizable silhouette of the horse showed all four feet above the ground at the same time. But he broke off from this work to leave on a long trip to South America after he was acquitted of murdering his wife's lover on the grounds of justifiable homicide.

On his return he took up action photography again. He had developed a new shutter design and used this to get a shutter speed of 1/1000th of a second, which gave him more detailed pictures. A 50ft long shed was constructed containing 12 cameras side by side, facing a white background marked off with vertical numbered lines. Each camera was fitted with Muybridge's high-speed shutter, released by an electromagnetic catch. Threads stretched across the track were broken by the horse as it moved along, setting off each shutter in turn. In about half a second, 12 images were produced demonstrating a sequence of movement.

EADWEARD MUYBRIDGE
(1830–1904)
The son of a coal and timber merchant, Edward Muggeridge first left England to seek his fortune in the United States in 1851. Changing his name in 1860, he settled in San Francisco and began to take photographs of the city and the landscapes beyond. Following the birth of his son in 1873 he was tried and acquitted of murdering a man whom he suspected was the real father. He made a grand panorama of San Francisco in 1877 using enormous 18×22in plates and the same year began his work on animal locomotion at the Palo Alto Stock Farm in California. Attracting worldwide attention for his work he continued to photograph the motion of humans, animals and birds, from 1884 under the auspices of the University of Pennsylvania. He returned to England in 1894 where he remained until his death.

recreating the effect

It is hard to imagine now how exciting and novel it was to see movement frozen as Muybridge was able to do. Now a galloping horse or a golf swing frozen in mid action is a familiar sight and recording the moving image grows easier and more available every day, with the ever more sophisticated technology of camcorders, compact cameras or even mobile phones. But that isn't to say that a sequence of stills such as these is obsolete. A series of stills presented together can give a fuller picture of your subject, slightly differing postures and expressions giving the viewer additional information, rather like Hockney's 'joiners', inviting individual examination of each 'frame' – details that might otherwise be overlooked in a moving image. Technically a motor-drive would make easy work of this nowadays. You would have to pan with the subject, and it's always better to shoot against a plain background.

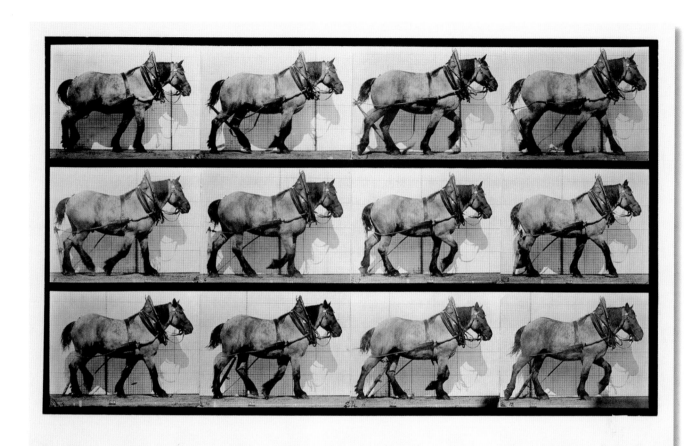

kurt hutton

Funfair, Southend, Essex, 1938 gelatin silver print

behind the image

Southend-on-Sea is a seaside resort on Britain's east coast, about 40 miles (65km) east of London. Famous for the world's longest pier and its other traditional seaside entertainments, it was a favourite destination for Londoners from the East End who would visit on day trips in buses and charabancs and occupy the boarding houses for their annual holidays. This image is one of light-hearted fun, working girls on a day out, showing the cheerful British spirit at a time of economic gloom and the threat of war. The billowing of the girl's skirt, revealing her underwear, is also in tune with the cheeky seaside humour of traditional British 'saucy postcards'.

The image was shot for a story in *Picture Post* magazine, Britain's leading illustrated magazine of the day, by one of its principal and founding photographers Kurt Hutton. Although *Picture Post* set the standard for serious photojournalism,

lighter material was also regularly included – you can't sell newspapers and magazines on news and politics alone; then as now, readers want to be entertained. Working-class entertainment such as this was a great source of photographs, showing people enjoying themselves at resorts like this or Blackpool in the North of England.

Hutton has constructed a wonderful composition using a wide-angle lens to exaggerate the perspective. Presumably having pre-arranged where the cars will stop (or perhaps they were never moving and the whole shot was set up), Hutton has placed the girl in the centre of the picture and chosen his viewpoint so that the cars of the ride lead our eye in from the bottom left and snake back into the distance behind the girls giving a dynamic sense of the ride having moved through the picture space towards us.

KURT HUTTON

(1893–1960)

Kurt Hutton was born Hübschmann and began his career with the Dephot photo agency in Germany. In 1934 he emigrated to England where he became a staff photographer for *Weekly Illustrated* and then went on to work as one of the original photographers on *Picture Post*. He continued to contribute to this groundbreaking magazine until it ceased publication in the late 1950s, during which time he did much to pioneer the language of photojournalism. Retiring to the coastal town of Aldeburgh in 1951, he became photographer to Benjamin Britten, the English composer who is strongly associated with the town and founded and ran a concert hall and festival nearby.

recreating the effect

Fairgrounds and amusement parks are great places to photograph people, with lots of interesting and colourful stalls and rides and, at night, illuminated with thousands of coloured lights. People are usually at their ease and won't mind being photographed, the problem today can be stopping them playing up to the camera – respect for the camera is long gone. For a shot like Hutton's a wide-angle lens is important to accentuate the depth, stretching things further apart and creating a sense of dynamism and movement. It means getting close to your subject though, which puts you rather more in the way and will make it harder to photograph unobtrusively.

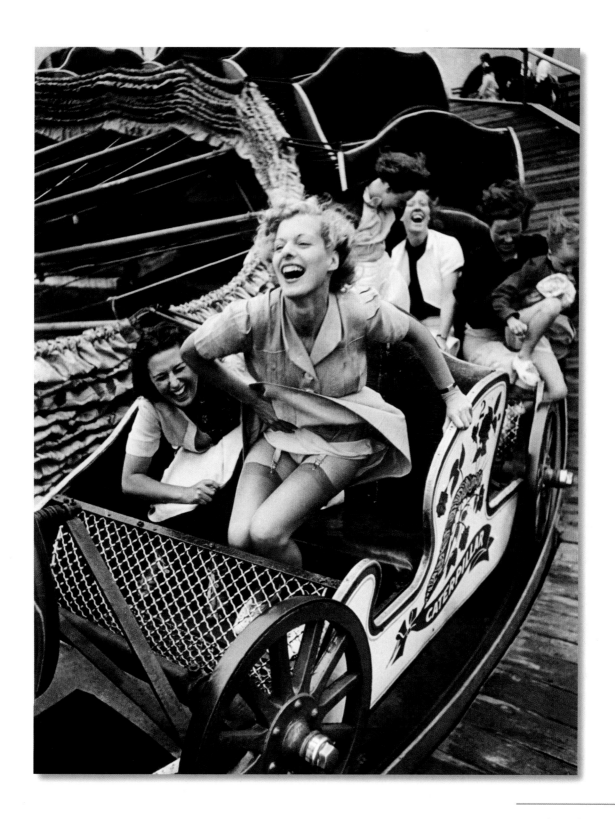

landscape and architecture

frederick evans

Sea of Steps, Wells Cathedral, 1903 platinum print

behind the image

Frederick Evans makes something of a departure from the architectural photography of the day with this, his most famous photograph; he has chosen to flatten perspective to create the carefully arranged composition rather than emphasize depth with a wide-angle lens. The purpose of the picture is not to describe what the steps leading to the Chapter House of Wells Cathedral are actually like, but rather to use the remarkable architecture as the basis

FREDERICK EVANS
(1853–1943)
Born in London, Frederick Henry Evans was an avid art and music lover and book collector from an early age. He began his working life as a bookseller, championing the work of George Bernard Shaw and Aubrey Beardsley, but retired from this in 1898 when he began his photographic career. In around 1900 he became a member of the Linked Ring of art photographers and was the first British photographer to be published in Alfred Stieglitz's famous journal, *Camera Work*. Evans simultaneously built a reputation as a pianist, often pointing out the surprising parallel between the demands of the two art forms – that of tonal control. An advocate of the platinum process, Evans ceased printmaking in 1915 during World War I as platinum became difficult to source commercially. He was made an honorary fellow of the Royal Photographic Society in 1928 and died in London two days before his 90th birthday.

for a new work of art with its own unique aesthetic and meaning.

Until the later part of the century photographers had tended to use wide-angle lenses just as one would today, to include as much of the scene as possible and also to emphasize the depth and perspective that photography was so good at capturing. This often meant taking up an elevated viewpoint, but Evans has placed his camera at eye level and flattened the perspective with a medium telephoto lens, making the steps look almost vertical and impossible to climb.

Despite the beautifully balanced tonality of this print, Evans resolutely refused to manipulate his negatives or prints in any way. He was not an experimenter – instead he was meticulous in the preparation and execution of photographs, which might require exposure times of several hours. Primarily interested in the play of light, there was no dodging and burning or tinkering with the negative, and in the interests of his 'pure' photography, he was happy with the subtle tones of the platinum process. Indeed he eventually gave up photography when platinum was no longer available.

Compositionally there is a fascinating tension between the strong horizontals of

recreating the effect

Evans was keen to capture the purity of the ancient stonework and, apart from the door at the back of the image and a glimpse of railing, there is only bare stonework and light in his picture. Similar locations these days are likely to have signs, railings, roped-off areas and other clutter which you would have to remove or work around to recreate the clean architecture of this shot. It's crucial to the picture to use a medium telephoto lens to flatten the perspective, and the image is also sharp from the front step right to the back of the composition so you would need a tripod, long exposure and the lens stopped right down.

the steps, the vertical piers in the upper right of the picture and the sweeping curve as the angles of the steps meet. The eye is led from the right, down into the picture and then up the steps towards doorways to the light beyond. A man of profound religious conviction, the metaphor for the spiritual struggle of this world towards the next would have been at the forefront of Evans's thoughts.

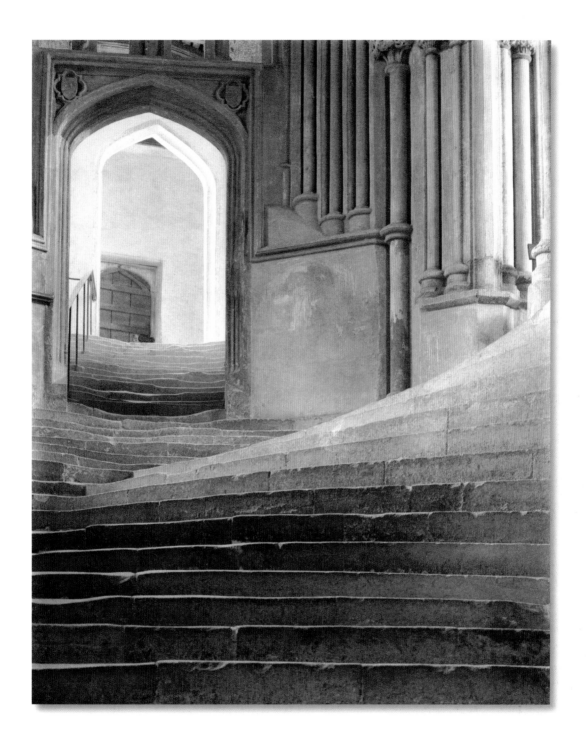

john blakemore

Mawddach Estuary, 1973 gelatin silver print

behind the image

In common with most of John Blakemore's work, this striking seascape is not intended to record a particular location but rather to describe the atmosphere and the emotion of the place. Here he is concerned with the power of the sea, the sunlight and the play of light on the water, rather than an identifiable landscape.

Working very much in the tradition of an artist, Blakemore produces long-running series of photographs, exploring the same subject, invariably in nature. In this image he is interested in the light, the texture and shape of the rocks, the brooding tones of the sky and sun on the water. Although he tends to use the most rudimentary photographic equipment, his images are always very carefully constructed and every detail of the picture-making and printing process is given the most minute attention. He is a devotee of the Zone System, as pioneered by Ansel Adams, and will have had a clear idea of how this print would turn out, setting his camera to record the scene exactly as he wanted it: dark tones, an almost-black sky with highlights on the water and the halo around the clouds, all being the precise

JOHN BLAKEMORE
(1936–)
John Blakemore became interested in photography while serving in the Royal Air Force in 1956 and resolved to become a photographer on seeing a selection of images from Steichen's 'Family of Man' exhibition. He worked as a freelance photographer until 1968 when he took a teaching post at the University of Derby. During the 1970s he established himself as one of Britain's leading photographers with a series of landscape photographs, as well as gaining a reputation as a leading teacher of the medium, influencing a new generation of British photographers. Other major bodies of work have included still lifes and a number of tulip pictures. More recently he has been working in colour and producing handmade books of his work.

recreating the effect

Blakemore has used a medium-format camera to take this photograph although he has also made extensive use of 35mm cameras during his career, and his general approach can be tackled just as well with a 35mm camera or digital SLR. The Zone System has a reputation for being complicated but the essence of it is to learn how increasing or reducing the exposure and altering the film development time will affect the tonality of the final print. Decide on the tonality you want and meter the various areas of the scene, by spot meter if possible, then decide how much more or less exposure you need for that area to render it as you would like. Filters could be used to accentuate the contrast in a scene like this, for example use a red filter for a dark sky. Burn and dodge to get the halo effect and balance the print overall in the darkroom or in Photoshop. A long exposure gives movement to the water; give it long enough and you can make it appear like mist flowing over the rocks, and stop your lens down as far as you can for maximum depth of field.

shades he had previsualized. In this photograph he has hidden the sun behind the cloud which has allowed him to shoot into the light – an all-important decision in terms of conveying the landscape's drama.

The quality of the print is very important and, a master in the darkroom, Blakemore works hard to create perfectly balanced prints, emphasizing certain areas by careful burning and dodging. In this image, for example, he is likely to have given the light halo around the cloud a little extra exposure in the darkroom to accentuate this key feature of the composition.

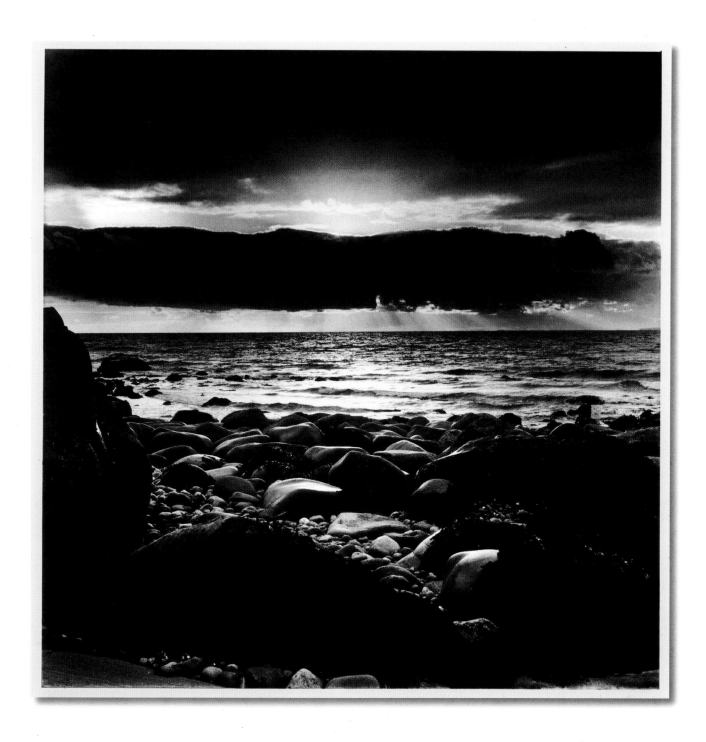

margaret bourke-white

George Washington Bridge, 1933 bromide print

behind the image

Revelling in the majesty of the structure, this photograph of the George Washington Bridge in Manhattan is one of a number Margaret Bourke-White took in and around New York in the 1930s. It expresses the grandeur of the enormous structure and uses the lines and curves of the bridge to lead the eye through the photograph. The roadway is invisible in dark shadow, forcing us to concentrate on the soaring structure and follow its flowing curves. Her use of a medium telephoto lens foreshortens the perspective and flattens the design, making the pattern appear more two dimensional.

Margaret Bourke-White was one of the first real stars of press photography and photojournalism, famous for exciting and dangerous adventures in the world's hot spots while working for *Life* magazine. In fact it was one of Bourke-White's photographs that appeared on the first cover of *Life*, for whom she worked for many years. It was an impressive photograph of the Fort Peck Dam in Montana, another proud symbol of American collective achievement and determination to make a better future at a time of widespread poverty and economic uncertainty.

But it was as a photographer of industrial subjects that she first gained recognition. She had been a student of Clarence H White, a member of Stieglitz's Photo-Secession and an advocate of Pictorialism, and she brought these artistic sensibilities to the business magazine *Fortune* in the early 1930s, making many

MARGARET BOURKE-WHITE
(1904–1971)
Born in New York, Bourke-White was introduced to photography by her father. He also encouraged her academic education and she attended several universities at the same time as studying photography under Clarence H White. She began her photography career in Cleveland, Ohio, focusing on industrial subjects, then moved to New York to work on *Fortune* magazine in 1929. She moved to *Life* magazine in 1935 and travelled all over the world on assignments, establishing herself as one of the world's leading photographers and doing much to set the style of modern photojournalism. The first woman war photographer, she was present at many historic events; one of her most famous images was the very last taken of Gandhi whom she photographed immediately before he was assassinated in 1946. In 1939 she married the writer Erskine Caldwell with whom she had collaborated on two books charting the effects of America's pre-war economic crisis, but they divorced three years later. She gave up photography in 1957 when she contracted Parkinson's disease.

recreating the effect

The principles of Bourke-White's photograph can be taken and applied to many subjects: using the lines and materials of modern architecture to make dynamic compositions – diagonals and curves working together or opposing each other. Bridges in particular often provide interesting architecture and opportunities for using unexpected angles and views or making unusual crops. The properties of different lenses can either be used to compress perspective (telephoto) and pull structures into more two-dimensional patterns, or conversely to accentuate it (wide-angle) making a line recede into the far distance. In this image, Bourke-White has kept the vertical steel pillars to the left and right absolutely perpendicular; it's easy when casually photographing tall structures to aim the camera upwards causing these verticals to converge towards the top of the picture. The trick is to keep the film plane (in most cases the camera) parallel to the structure.

celebrated photographs that expressed the romance of industry. These architectural photographs present a positive and optimistic view of American engineering achievement at a time when good news was in short supply. The 1930s may have spawned some of New York's most famous landmarks, the Chrysler and Empire State Buildings for example, but outside these grand projects precious little was built in New York during these years of depression.

peter henry emerson

Rowing Home the Schoof-stuff, 1887 platinum print

behind the image

The schoof-stuff of the title is local Norfolk dialect for poor quality reeds that were no good for thatching. This study is one of many Emerson made on extended trips to England's Norfolk Broads (a large area of wetlands and interconnecting lakes) while working on two books with the painter T F Goodall: *Life and Landscape on the Norfolk Broads* (1886), and *Idylls of the Norfolk Broads* (1887). They lived on a boat called *Maid of the Mist,* enduring often freezing temperatures, and many times during the trip the broads froze over, the temperature dropping to minus 20°C. They travelled all day, writing and taking photographs, returning to the boat at night to develop the negatives.

Emerson believed passionately that photography should present subjects in a simple, direct style and argued that a photograph should imitate nature, rather than alter it, without manipulation by the photographer either in the camera or in the darkroom. 'We must see the picture in nature and be struck by its beauty so that we cannot rest until we have secured it on our plate.' Emerson's aim was to achieve a timeless vision of a land and its inhabitants. He wanted to show people engaged in traditional labours and pastimes. And indeed this photograph feels as though it could have been taken a hundred years earlier.

At the service of naturalism, Emerson argued that a photograph should imitate the eye. He claimed that one only sees sharpness in the centre of our vision and sight is slightly blurred on the periphery. Therefore one should make a photograph slightly out of focus in order to achieve this

effect, keeping sharpness only on the main subject. 'Nothing in nature has a hard outline,' he wrote, 'but everything is seen against something else, and its outlines fade gently into something else, often so subtly that you cannot quite distinguish where one ends and the other begins.'

Emerson used half-plate or whole-plate cameras and, for that special shot, a 22×24in (neg size) camera. Emerson would have had to get very close with his plate camera to take this picture and had to strap his tripod to two eight-foot poles pushed into the reed bed for steadiness.

recreating the effect

From a modern perspective getting close to an awkward subject like this is not as difficult as it was for Emerson. With a long telephoto you could stand at a comfortably safe distance and focus on the boat out in the water. To retain the wide view though, you would probably need at least a standard or medium wide-angle lens which would necessitate getting out on the reed beds as Emerson did. Using a wide aperture, the background can easily be thrown out of focus keeping the subject or the point of interest in focus, which would be faithful to Emerson's ideal. Emerson's own photographs were platinum prints, a process renowned for its beautiful tonal range and textured surface. Unfortunately use of the process largely died out in the 1920s due to the rarity and expense of platinum but enthusiasts and fine art photographers have revived it in recent years.

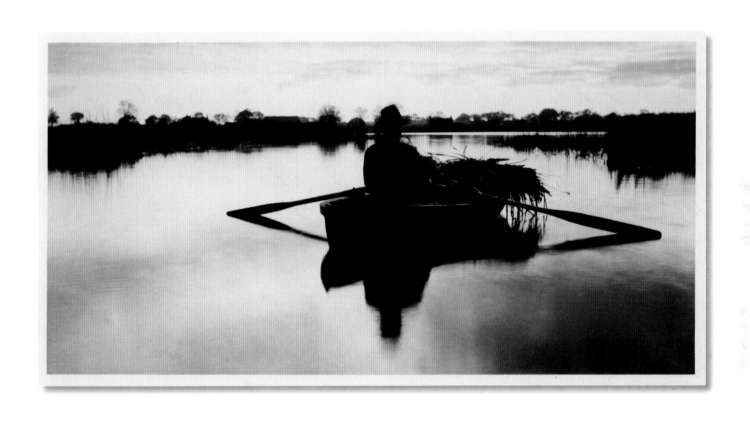

josef sudek

Prague in Winter, 1955 gelatin silver print

behind the image

This beautiful view is one of a series of panoramic images Sudek, the most poetic of photographers, took of his native city Prague during the 1950s. His personal vision of the place was turned into the book *Panoramic Prague* (1959) – a portrait of a city to rival Atget's images of Paris.

The scenes he captures are invariably empty or barely peopled – everyday locations imbued with a mystical tranquillity – a human presence subtly referred to in this case by the bench and two figures in silhouette to the right of the image. Sudek had a very particular vision and realized it with highly specific equipment. He used heavy and unwieldy, often elderly, cameras such as the panoramic for this picture, very unusual for the time. What makes this more remarkable, and would have made him even more distinctive as he walked around lugging this large camera and wooden tripod, was his one arm – he lost the other while fighting for the Hungarian army during World War I.

His camera was an 1894 Kodak Panorama, whose spring-driven sweeping lens made a negative of 10×30cm (almost 4×12in). The camera was capable of photographing a full 180-degree

JOSEF SUDEK
(1896–1976)
Born in Kolin, Bohemia and trained as a bookbinder, Sudek lost an arm in World War I and was therefore unable to return to his trade. His disability helped him gain a scholarship to study photography in Prague in the early 1920s. He worked initially in a Pictorialist style but was keen to innovate and founded the progressive Czech Photographic Society in 1924. He became successful commercially during the 1930s and also established himself as one of the leading figures of Czech art. The Nazi invasion in 1939 changed the cultural climate, and during and after the war Sudek worked on a series of views of his native countryside and panoramas of Prague. These were not published until the late 1950s and Sudek's reputation in the West was not secured until a former student championed his work in America in the 1970s.

recreating the effect

Panoramic cameras have been around for over a hundred years as is proved by the fact that Sudek used one made in 1894, but for most people their physical size and awkward operation, not to mention expense, has made panoramic photography the province of the specialist. Like so many things, that no longer needs be true; the advent of digital technology has meant that you can create panoramas by stitching digital images together. Take a series of photographs by standing in one place and make your way slowly around an arc, keeping the horizons as even as you can and overlapping each frame by around 40 per cent; a tripod would help. But there are also more user-friendly versions of panoramic cameras available, notably the Hasselblad Xpan which takes ordinary 35mm film and is switchable between a panoramic and ordinary format. Unless you want to make a particular virtue of it, 35mm or even medium-format cameras will not give you very impressive contact prints as they are just too small, but the haunting effects of Sudek's sombre tonality are worth trying to recreate with careful attention to the exposure time when you take the photograph.

panorama and was equipped with only two shutter speeds, fast and slow. Sudek had become intrigued with the quality of old prints and almost exclusively made contact prints, the panoramic camera giving him fine quality prints of a good size – compared to a 35mm film the negative is of course huge. He was not afraid to make very dark and sombre prints, also using toned papers, and this solemn mood, with the fine detail and tonal variation of his process, is partly responsible for the haunting quality of his photographs.

samuel bourne

Interior of Moti Masjid, Agra, *c.* 1865 albumen print

behind the image

This photograph shows the interior of the Moti Masjid at Agra Fort, India. The 'Pearl Mosque', built entirely from marble in the mid-17th century, is acknowledged to be one of the most beautiful mosques in India.

Bourne's careful composition places a kneeling man at prayer and a man in a turban behind him, presumably facing towards Mecca. By choosing to place them in the middle ground, Bourne accentuates the enormity of the architecture, stressing the acres of space in front and behind them. The perspective of the long, ornate corridor is the main feature of the photograph, with the carved archways receding into the distance drawing the eye through the picture, to the door at the back of the scene.

One of the first intrepid explorer photographers, Bourne is best known for his Indian photographs, taken over a period of six years in the 1860s. He was well known at the time for reaching far-flung corners and making photographs in the extreme conditions of Kashmir and the Himalayas. As he recorded in the *British Journal of Photography* 'it [India] is altogether too gigantic and stupendous to be brought within the limits imposed by photography'. But interestingly it was his strong commercial instinct that dictated his choice of views, presenting the picturesque colonial view of India rather than attempting a more realistic portrayal

of the local population and their way of life. The two figures in this composition suggest a hint of the local culture and its people but only in the most controlled way. He chose instead to emphasize the grandeur and picturesque qualities of the Indian architecture.

Bourne's achievements are all the more impressive given that he used the collodion wet-plate process, which required very long exposures, large heavy cameras and plates, as well as a dark tent that had to go everywhere with him so that he could develop the plates on the spot. His trips were managed with great efficiency; he often had a troupe of over 50 porters to carry the heavy equipment as well as a number of sheep, goats and other provisions to cater for his entourage.

SAMUEL BOURNE
(1834–1912)
Born in Staffordshire in England, Bourne took up photography as a hobby at first. He made a photographic tour of the Lake District in 1858 and his photographs were favourably received when exhibited the following year in Nottingham and then later in London. In 1862 he left for India and set up the successful photography practice of Bourne and Shepherd in Calcutta. While in India he travelled and photographed extensively. He made a point of going to remote and previously uncharted locations, and encouraged interest in his photographs with a series of articles in the *British Journal of Photography* between 1863 and 1870. He briefly returned to England to marry in 1867 and finally left India in 1871 to settle in Nottingham where he went into the textile business with his brother-in-law. He continued with his photography as a hobby and also turned to watercolour painting until his death in 1912.

recreating the effect

A challenge with travel photography today is to capture scenes that are devoid of tourists. Nobody wants to go to a crowded city or beach and it's invariably the job of the travel photographer to make a scene attractive to the prospective traveller. As so often with photography, an early start is your best chance. Constructing a composition like Bourne's with characters placed in the scene is also very difficult to arrange but the results can often be arresting and sometimes convey a timeless impression, so different to the more expected reportage style. One of the themes of Bourne's photograph is the repeating pattern of the architecture and this makes for a striking composition. Look for recurring patterns and colours in architecture and use long lenses to foreshorten the perspective and give the scene more drama. And of course an obvious feature of Bourne's picture is the distinct coloration that could be recreated in Photoshop or by sepia tinting if you wanted to try to get that antique quality.

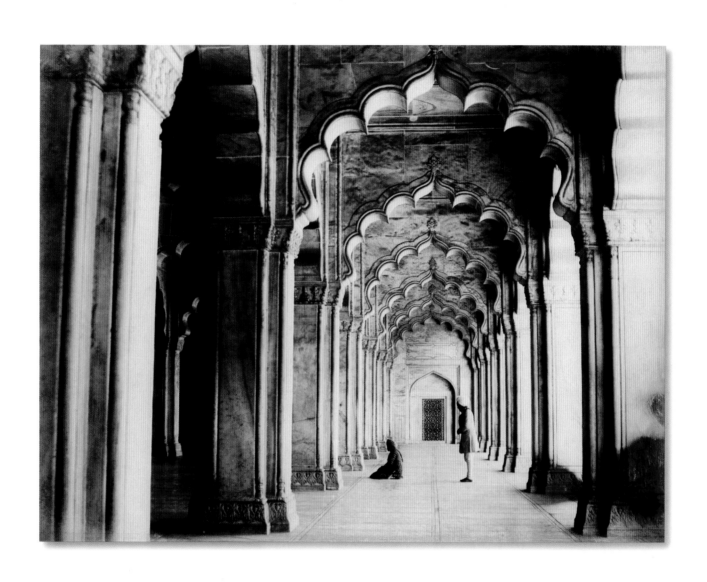

fay godwin

Large White Cloud, Kent, 1981 gelatin silver print

behind the image

This is a celebration of the English landscape – a subject that was the principal theme throughout Godwin's career. The perfectly balanced square-format composition uses the furrows of the field to draw the eye in and across the bottom half of the frame and out to the explosion of light in the bright sky. The wonderful cloud formation that dominates the image is balanced by the solitary tree to the left.

Godwin was a keen rambler who had begun her landscape work taking pictures for walkers' guidebooks. This picture is from her most significant body of work, *Land*, which was both a major exhibition in 1985 and the title of her book. On the face of it this picture is in the Romantic aesthetic landscape tradition, showing Britain as a beautiful, if perhaps empty or abandoned, place. There are no man-made objects, no telegraph wires, no

roads – the only influence of man are the lines of the crops and the two tiny gates in the centre of the frame. But later photographs, and her commitment to the rights of walkers to roam in the countryside, perhaps cast this work in a more political light.

Godwin's theme is our relationship with the land; ideally a harmonious and mutually beneficial partnership, but increasingly she was angered by modern commercial exploitation, industrial damage and creeping development. A campaigning point of view may not be evident in this image and indeed Godwin's own political views were not overtly stated until her later collection *Our Forbidden Land*, but perhaps in hindsight it is implied by the omission of man-made elements.

The strength of the print is its extraordinary tonal range, achieved after painstaking work in the darkroom. The

FAY GODWIN
(1931–2005)
The daughter of a British diplomat and an American artist, Godwin was born in Berlin, Germany and lived all over the world as a child. She settled in London in 1956, working in publishing and marrying Penguin Editor-in-Chief Tony Godwin. She became interested in photography as the result of taking pictures of her children in the 1960s and her first professional work was taking portraits for book jackets, and landscape photographs to illustrate walking guides. Dissatisfied with the printing of her photographs she held an exhibition of her work and published her first book *The Oldest Road* in 1975. In 1979 she collaborated on a book with the poet Ted Hughes and her reputation as one of Britain's leading photographers was assured by the time of the major exhibition and publication of *Land* in 1985.

brightest highlight of pure white is reserved for the top of the cloud formation, with the silhouette of the lone tree an almost featureless black. Godwin would have used a Hasselblad square-format camera mounted on a tripod and then stopped down the camera lens to maintain sharpness throughout the photograph. But the real trick, as any landscape photographer will tell you, is waiting for the right moment. The cloud is the main story of the picture and has been meticulously placed in the frame. As one critic who dared to suggest that Godwin had been lucky to catch a perfect sky in one of her photographs found out, 'I didn't catch it, I sat down and waited three days for it.'

recreating the effect

The best landscape pictures are rarely taken from the most accessible spots. You must be prepared to hike out to the best vantage points, which may be hours of walking from the nearest road. Keep the weight of your equipment to a minimum – use a rucksack, leaving your hands free – and you'll walk further, see more and take more pictures. Patience and the ability to compose with minute attention to detail are key, regardless of what format camera you use, as well as an understanding of the weather and the light. Knowing the time of day or year when a particular view will be best lit, and how cloud formations, sunrises or sunsets are likely to develop with the changing weather, will significantly improve your chances of capturing a spectacular image such as this.

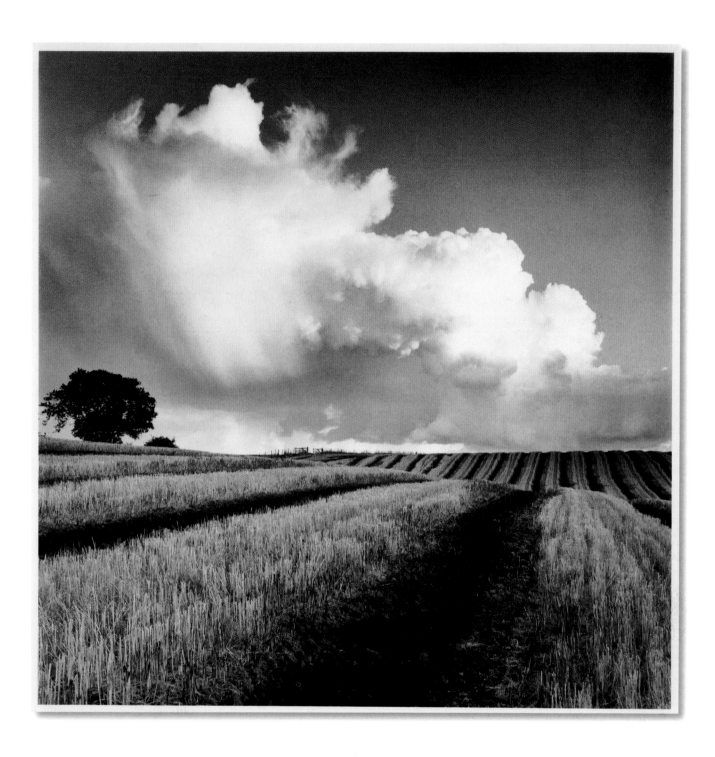

paul strand

The White Fence, Port Kent, New York, 1916 photogravure

behind the image

Taken on a trip to Lake Champlain in upstate New York, Strand considered this picture to be among his best and it exemplifies the radical modernist approach that made his name. Strand was championed by the influential Alfred Stieglitz at whose gallery he would have come into contact with other important photographers such as Clarence H White and Alvin Langdon Coburn; he would also have been exposed to the work of artists such as Cézanne and Picasso, whose influence is clear in his treatment of space in this image. In his earliest work he had followed the example of photographers such as Clarence H White but, criticized in 1915 by Stieglitz who had lost faith in the soft Pictorial style, he developed a dramatic new modernist approach.

Strand has reduced the perspective to a flat plane, the bright white of the fence and the dark areas of grass behind treated as strips of dark and light of equal weight. The buildings at the back seem to float in the air above the fence. It was a clear statement of his own new vision: 'From it I learned how you build a picture, what a picture consists of, how shapes are related to each other, how spaces are filled, how the whole must have a kind of unity.'

It was not for purely formal reasons that Strand was first attracted to the fence: '[it] fascinated me. It was very alive, very American. You wouldn't find a fence like that in Mexico or Europe. I have aesthetic means at my disposal, which are necessary for me to be able to say what I want to say about the things I see. And the thing I see is outside of myself – always. I'm not trying to describe an inner state of being.'

Strand used an English-made Ensign reflex plate camera, 3¼×4¼in, which with a tripod was a large and unwieldy machine. The cumbersome nature of the equipment perhaps encouraged Strand's carefully constructed approach.The photograph was printed as a photogravure in Stieglitz's magazine *Camera Work*, from which our illustration is reproduced.

PAUL STRAND
(1890–1976)
Born in New York, Strand was taught photography by Lewis Hine who took his students to see the work of Alfred Stieglitz at the 291 Gallery on Fifth Avenue. Stieglitz and subsequently Picasso and Braque had a great influence on Strand. His early images were very direct representations of street scenes, concentrating on the formal structure, arranging shapes, patterns and forms. In later work he moved to a more documentary style, most famously photographing communities in southern Italy and the Hebridean Islands. A committed socialist, during the 1930s he visited the Soviet Union where he met Sergei Elsenstein and other Russian artists. During this period he also worked extensively as a cinematographer for both the US and Mexican governments, but returned to still photography full time in 1943. He lived in France from 1951, fearing the anti-Communist witch-hunts in the United States.

recreating the effect

Strand was able to achieve the best possible quality by using a large-format camera but the real strength of his photograph is compositional and about the arrangement of elements within the frame. A medium to long lens would foreshorten the distance between the fence and out-of-focus buildings, and bright sunshine would be essential for the brilliant white of the fence and placing the barn in dappled shadow. Strand's methods of using building blocks of tone can be applied to many different subjects as can the idea of photographing something as quintessentially American as the white fence. It's about choosing a subject that embodies the spirit or identity of a place.

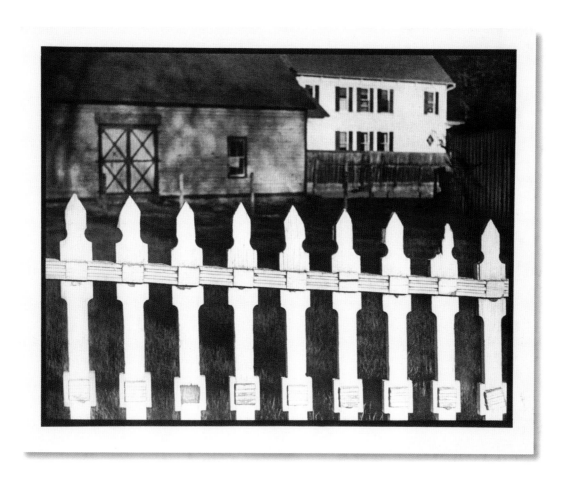

francis frith

The Sphinx, 1859 albumen print

behind the image

Frith wanted to show people in England something they were unlikely ever to see for themselves and this view of the Sphinx and pyramid would have been a startling sight for the Victorian public. In today's culture we are saturated with images from all over the world and little surprises us but Frith was quite literally at the forefront of travel photography, inventing its vocabulary as he went. At the time his photographs would have been extraordinary, illuminating a world that people didn't know existed. He wanted to express the grandeur of foreign destinations, and rather than minutely describing the location, he was more concerned with expressing the feeling of being there.

FRANCIS FRITH
(1822–1898)
Born into a Quaker family in Derbyshire, England, Francis Frith was apprenticed to a cutlery manufacturer before starting a business as a grocer in 1845. He ran this successfully until 1856 when he sold up – making himself extremely wealthy – to concentrate on his hobby, photography. He undertook three photographic journeys to the Middle East and his work was widely praised and sold successfully as prints and published books. Having settled in Reigate in Surrey, from 1860 he embarked on a project photographing every town, village or notable site in Britain. He subsequently established a postcard business that became one of the largest in the world. He died in Cannes, France in 1898 and the firm continued in family hands until the 1960s.

The composition he chose is straightforward; the sphinx's head is balanced perfectly by the pyramid in the background. The harsh and unsightly shadow under the head is not ideal though, and tells us that the photograph was taken around midday.

Frith was a competent and ruthlessly determined photographer. As a Quaker he saw these trips as harsh physical pilgrimages and part of his own religious mission; he had to battle against the overwhelming heat with temperatures reaching 130°F, dust and flies as well as bandits along the way. He used very large and awkward cameras (the biggest plate was 16×20in) and the wet collodion process, which could yield extremely detailed results. Cumbersome as this equipment was, he did extremely well to use it in hot and dusty environments.

An oriental craze had hit England in the 1850s and even the mild Frith, complete with huge beard, was reported to have dressed up in Turkish costume on more than one occasion. Oriental subjects sold well and Frith (a successful businessman) was quick to see the possibilities. The pictures were published as books and sold as prints and *The Times* declared them the most important photographs ever published; he was said to have made almost £25,000 from the venture.

recreating the effect

It would be impossible to get this picture now, not least because the Sphinx is no longer buried by sand up to its shoulders as shown here. While Frith had the luxury of being the first to photograph these iconic places, it's still possible to make an arresting image – you just have to try harder to find an original view, so think about the feelings that the place evokes and try to find an outlook or vantage point that will help you convey this with your composition. Generally it's best to avoid the midday sun for landscape work; the light of early morning or evening is much more interesting to work with – it's clearer, and it will offer shadows, depth and detail with good modelling on your subject. The physical problems of some environments can be acute; be careful with sand in deserts and on beaches. It gets everywhere so bag up or wrap your cameras when not in use.

THE SPHINX.

ansel adams

Moonrise over Hernandez, New Mexico, 1941 gelatin silver print

behind the image

This is one of the most famous photographs ever made, reproduced innumerable times on calendars and cards and prints of various description. The theme is nature as the dominant force, the huge sky and landscape dwarfing the small New Mexican town of Hernandez. The point is further made by the gravestones in front of the town, making the short lives of the inhabitants seem insignificant next to the timeless enormity of the landscape and the elements. The power of the image embodies what Ansel Adams was so passionate about: the elemental beauty of the American landscape, and he realized and exploited the potential for his images to be political tools to lobby politicians with his concerns about conservation.

Adams was, above all, a perfectionist and master craftsman. He understood the impact of the scenes he photographed and did everything he could to record them perfectly. Devoid of human presence, his landscapes are always pristine. He was interested in 'pure' photography, wanting to represent his vast landscapes with absolute clarity, and the equipment he used reflects this. Adams made the images with a large plate camera on a tripod, often perched on the roof of his huge estate car to get the views he wanted, using small apertures and long exposures for total sharpness. The group he co-founded to promote this style of photography was

even named after the smallest aperture on these huge cameras: f.64.

The dark brooding sky in this image is a good example of one of his most important contributions to the history of photography – the Zone System – his means of codifying how certain camera settings and film development times would affect the final photograph. Put simply, the range from pure black to pure white is split into ten shades or zones. If Adams decided he wanted a certain tone to record as very dark but not pure black (e.g. Zone II) and he knew that under 'normal' exposure it would record as a mid-grey (e.g. Zone V), he would then reduce his exposure accordingly in order to achieve the tonality he wanted. The tonal range of the negative is then determined by the development time. In this way he was imagining the way his print would look, even though this

ANSEL ADAMS
(1902–1984)
Trained as a pianist, Adams turned to photography in 1927, taking his first pictures while visiting Yosemite Park, California. He was influenced by photographers such as Paul Strand and Edward Weston and the idea of faithful, natural or 'pure' photography. He was concerned for the conservation of the natural environment and is chiefly known for his pictures of the parks, canyons and deserts of the American West. A founding member of the influential Group f.64, his deep interest in the process of photography led him to invent the Zone System to accurately predict (or 'previsualize') the tonality of a print before making the exposure, and to write a series of books on photographic technique. He was also instrumental in setting up the photography department at the Museum of Modern Art in New York and the influential Aperture Foundation.

may not be how the scene before him appeared. He termed this 'previsualization' and ultimately it gave him the means to control the tones of an image for dramatic effect.

recreating the effect

If you really want to replicate Adams' methods, you need to use a large-format camera, but unless you want to make enormous prints, pin-sharp results can be achieved today with SLR cameras or, better still, a medium-format camera. A tripod is essential to ensure absolute sharpness throughout the frame and to enable you to use slow shutter speeds and shut the aperture right down. A medium telephoto lens would foreshorten the perspective – in other words, bring the land, sky and town closer together. The Zone System requires experience to use effectively; although the principles are easy enough to grasp, you need to know exactly how your own equipment performs so that you can confidently predict the effects of altering exposure and development times.

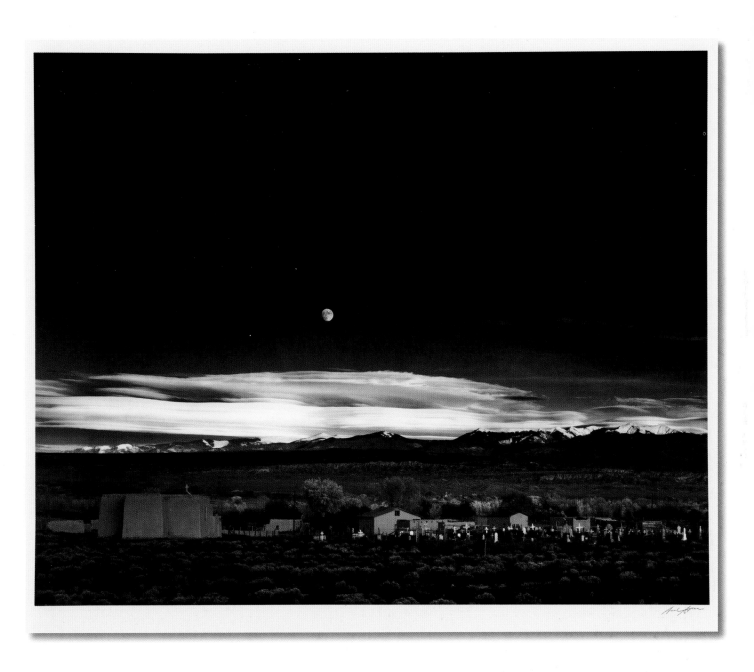

george davison

The Onion Field, 1896 photogravure

behind the image

This famous view, originally known as *An Old Farmstead*, was taken using a pinhole camera, which is what gives it the distinctive, slightly out-of-focus effect. The photograph caused a sensation when it was shown at the Photographic Society of Great Britain in 1890 – the blurred image made with this radical technique was taken almost as a deliberate joke and a slight on the art of the lens makers; some even deemed it not to be photography at all.

But Davison was a leading figure in the Pictorialist movement of the late 19th century and was interested in producing pictures of aesthetic and emotional content rather than simply accurate records of what lay before him; he wanted to be thought of as an artist-photographer rather than an operator of a scientific instrument. In this way, *The Onion Field* was the first example of 'impressionism' in photography rather than sharp focus 'reality' and followed the movement in painting that had begun in the 1860s and dominated the later part of the 19th century. It was with this painterly approach in mind that in 1892 he became a founding member of The Brotherhood of the Linked Ring – a break-away group from the Royal Photographic Society – that espoused the Pictorialist ethos. However, Davison's purpose in creating impressions was not merely frivolous or art for art's sake; he also felt that conveying a sense of atmosphere and emotion in an image was a better way of eliciting empathy with his subject – often working people, their living conditions and labours.

GEORGE DAVISON
(1854–1930)
Born into a working-class family in Lowestoft, Davison first worked as an audit clerk in London. He took up photography in 1885 when he joined the newly formed Camera Club in London. He soon became its honorary secretary, a post he held until 1894. He began to exhibit photographs in 1886 and became a regular prizewinner at photographic exhibitions. He was a passionate supporter of naturalistic photography in the argument of the day between impressionist-like images and sharp focus, and an important spokesman for the cause of photography as art, eventually leading a break-away group from the Royal Photographic Society to form the Linked Ring group of photographers. He became a director of the Eastman Photographic Materials Company in 1889 and in 1900 became managing director of what had by then become the British division of Kodak. Following retirement he put his energies into promoting various anarchist, socialist and communist political activities. Having become extremely wealthy through his association with Kodak, he spent his last years at his holiday home in the South of France.

recreating the effect

Using a pinhole camera is the most basic and simple form of photography, and employing the same technique today can be both refreshing and rewarding. You can put a pinhole in any light-tight container that will hold a light-sensitive piece of film or photographic paper. Rather than making the box itself you could use your SLR and make a pinhole aperture to fit over where the lens would usually attach – or perhaps adapt a body cap for a tidy solution. The hole needs to be as neat and consistent as possible; with such a small aperture, long exposures are necessary for a good image. You tend to be working blind and you need to experiment to get the correct exposure. A digital SLR would be a tremendous advantage here, allowing trial and error. Without the lens to focus light, the image will not be pin-sharp, but unlike traditional photography, where there's a plane of focus with things out of focus in front and beyond, the image will be consistent throughout.

The faint images produced by the pinhole process were not well served by early photographic materials and it was only with the introduction of far more sensitive films in the 1880s that it became possible to get very good results from pinhole cameras. This print is a photogravure – a process in which Davison was highly skilled; it involved transferring the image from the negative to a copper plate before printing. The plate was then inked and large numbers of finely detailed prints could be made from it.

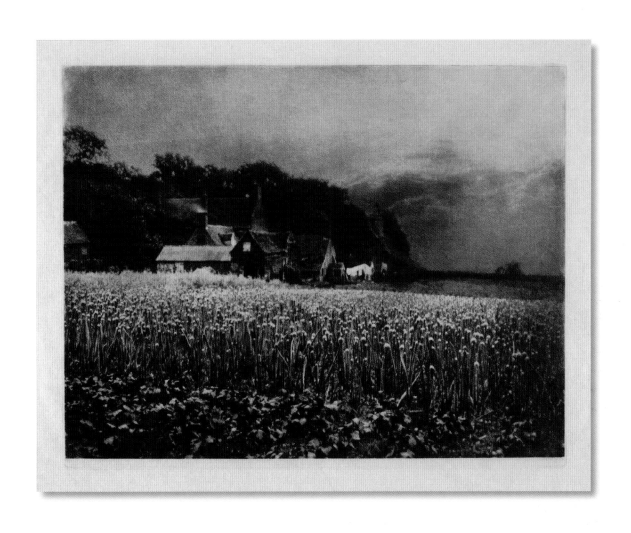

photography
as art

alvin langdon coburn

Vortograph, 1917 gelatin silver print

behind the image

There are few clearer examples of a photographer aligning his work with movements in art than Coburn and his Vortographs, his most famous images. They are the result of direct influence by the group of English artists known as Vorticists, the leading exponent of which was Wyndham Lewis. Closely related in style to the fragmentation of Cubism and in spirit to the Futurists' portrayals of the modern, mechanized and urban world, they sought to capture the pace and dynamism of contemporary life and the exciting geometric forms of industry, technology and architecture.

To create similar two-dimensional images with hard-edged fragmented shapes like the Vorticist painters, Coburn developed a technique using a kaleidoscope-like device of three mirrors placed in front of his lens, which broke his subject up into geometric patterns. Although he also used this method for portraits, in the most famous of his Vortographs the subject is a crystal, the facets of which lend themselves to the fragmented kaleidoscopic effect. The resulting geometric patterning is also reminiscent of the Art Deco movement that would dominate design styles in the 1920s and 30s.

A cousin of Fred Holland Day, Coburn had established his reputation as a photographer in America. Always concerned with the production of photography as a legitimate art form, he had been one of the original members of Alfred Stieglitz's Photo-Secession, promoting the cause of photography as art. His work had been moving towards

abstraction in 1912 when, inspired by a trip to the Grand Canyon, he photographed New York from its highest vantage points, stressing the patterns of the streets and buildings as seen from above. Moving to London the same year where, thanks to earlier introductions by Fred Holland Day, he was already in touch with artistic circles, he came into contact with the Vorticists and took the final step towards entirely abstract photography. It was at the Camera Club in London that he first exhibited his Vortographs – the first examples of truly abstract images in the history of photography.

recreating the effect

Abstraction is not something that most photographers are aiming for, but Coburn's earliest examples show how simply photography can be manipulated to yield compelling abstract images. Bouncing your viewpoint off mirrors or photographing through interestingly shaped glass objects such as glasses or vases is a literal way of following Coburn's example, but abstraction can be obtained without distortion by photographing interesting natural or man-made shapes in extreme close-up. Without sufficient context, almost anything can become abstract. And of course computers have made the kind of image manipulation that Coburn worked hard to create in-camera, much simpler to achieve, cloning and repeating parts of an image, creating reflections and repeating patterns at the touch of a button.

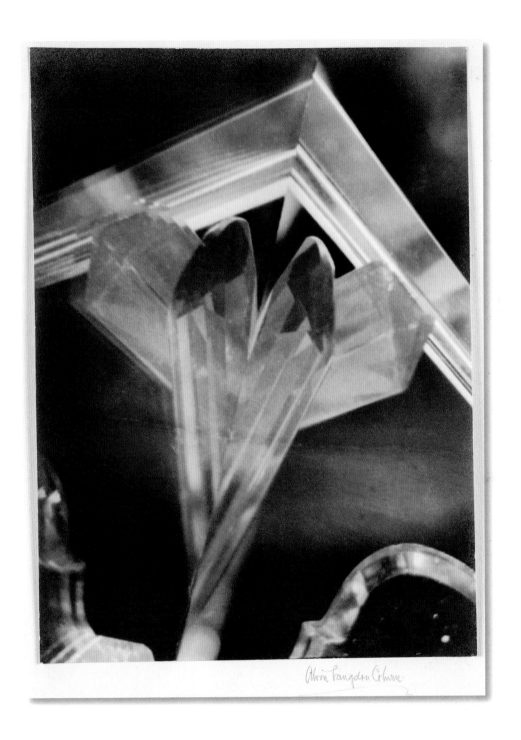

roger fenton

Still Life with Ivory Tankard and Fruit, 1860 albumen print

behind the image

Outwardly simple, this beautifully executed still life is much more than a study of shape and form – it is packed with meaning and symbolism. Fenton had originally trained as an artist and brought a deep understanding of art history to his later photography. His still lifes therefore draw on the traditions of painting, and particularly on Dutch artists such as Jan van Os.

The symbolism of this particular tableau is Bacchanalian, but very similar subject matter in other still lifes by Fenton stressed Christian symbols. A chalice, bread and fruit associated with Christian rituals are subtly altered in this scene so that it is not about Christianity at all, but the joys of the

flesh. The ivory cup is overturned and empty, implying consumption and even abandon, and the grape is symbolic of wine. The melon is in a state of decay and beginning to go rotten, the pineapple adds exoticism to the scene, and it has been suggested that the two peaches have been placed next to the figure on the cup's lid to echo and make reference to its buttocks. The whole scene adds up to one of indulgence and debauchery, a morality tale depicting the evils of over-indulgence.

Despite his background in art, Fenton was actually one of the first commercial photographers. Having initially experimented with photography after seeing the Great Exhibition in 1851, using the waxed paper process and salted paper prints, his technical success in this difficult process led to his becoming official photographer to the British Museum in 1854. The photographs he made of the objects in the collection and also his views of Russia and England were sold through dealers to the general public. He also made a famous series of photographs of the Crimea during the war, qualifying him as the first war photographer.

His series of celebrated still lifes were probably all the result of a single session as it appears to be the same fruit that has been used in several of the images. Fenton clearly wanted to have the kind of

ROGER FENTON
(1819–1869)
Born in Lancashire to a wealthy family, Fenton studied painting with Edward Lucy and later Edward Delaroche in Paris. He qualified as a lawyer, still painting in his spare time but became increasingly interested in photography. He photographed views in England and travelled to Kiev, Moscow and St Petersburg. In 1853 he helped found the Photographic Society in London as its honorary secretary. He photographed Queen Victoria's children at Windsor Castle in 1854, and the following year went to the Crimea to photograph the war producing several hundred compelling images. From the mid-1850s he continued to photograph the English landscape, then turned to genre studies and still lifes before abandoning photography altogether, selling his equipment and negatives in 1862.

recreating the effect

You have ultimate control when photographing still lifes and there is no excuse for anything not being where you want it or the light not being exactly to your requirements. Using a medium telephoto lens (an 80mm lens on a 35mm camera for example) allows you to work from a comfortable distance and frame your composition just as you want. The subject is not likely to be going anywhere so you can choose long exposures and put your camera on a tripod to ensure absolute clarity and exact framing. To get even illumination throughout I would use reflectors or white card so as to bounce light back into the shadow areas.

control over his photography that a painter has over his work. After his experiences of landscape and travel photography, he perhaps felt that this was the only way in which he might be considered an artist – by being in complete charge of his subject's arrangement, framing and lighting. He worked with large cameras – often with glass plates as big as 35×45cm – and the resulting quality of some of his albumen contact prints from these very detailed negatives would be difficult to match even today.

Photographed by R. Fenton

edward weston

Nude on Sand, Oceano, California, 1936 gelatin silver print

behind the image

Contrary to the advice that is given in modern photographic manuals, Weston chose to take this photograph with the midday sun directly overhead. The usual theory is that the midday light is harsh, too contrasty and the shadows too short to reveal shape and modelling. But Weston has used these factors to his advantage, the sand appearing to be almost featureless and merging with the tones of the nude's body, which is picked out in the pencil-thin lines of deep shadow cast by the bright sunlight.

With a 10x8in camera and meticulous attention to detail he pursued perfect precision, setting out to capture the 'vital essence' of things. His simple pictures of peppers, dead birds and eroded planks on the beaches of California changed the way that we look at these familiar everyday objects. A founding member of the American Group f.64 advocating 'pure', sharply focused photography, he applied his technique rigorously to render his subject with absolute clarity whether it be a nude, landscape or vegetable.

Many of his nude studies, including this one, were of his second wife Charis Wilson who accompanied him on his photographic expeditions in California. In his famous *Daybooks* dated 9 December 1934 Weston wrote: 'The first nudes of C. were amongst the finest I had done, perhaps the finest.' She was then twenty and for the next ten years she lived with and posed many times for Weston.

EDWARD WESTON
(1886–1958)
Born in Illinois, Weston began to make photographs in Chicago in 1902, and his work was first exhibited in 1903 at the Art Institute of Chicago. He later moved to the west coast, opened a portrait studio in California and began to photograph the Western landscape. He travelled to New York in 1922 and met Alfred Stieglitz and Paul Strand, and in 1923 opened a studio in Mexico City where he came into contact with artists such as Diego Rivera; it was there he made a number of portraits of his assistant and lover Tina Modotti. Back in California by 1926 he started to produce his highly influential images of landscapes and natural forms such as peppers, shells and rocks, and went on in 1932 to form the influential Group f.64 with Ansel Adams and Imogen Cunningham, among others.

recreating the effect

The requirements for a shot like this are a beach, a bright sunny day and a close friend or lover who feels comfortable taking their clothes off. Wait until the sunlight is directly overhead so that shadows almost disappear and any subtle undulations in the sand become invisible. To further accentuate the flatness of the composition, Weston has taken a high viewpoint to shoot back down on the model. Although not usually recommended, overhead sunlight can give forms boldness, with bright highlights and shapes outlined with sharp thin shadows. Sometimes using overhead light is essential: for example, when photographing buildings to avoid shadows from neighbouring structures falling across your subject.

albert renger-patzsch

Timber Yard, 1929 gelatin silver print

behind the image

An uninspiring choice of subject you might think, but Renger-Patzsch has chosen this stack of wood in an industrial yard for very particular reasons: to demonstrate how 'things' conform to a certain universal order, and that photography is the best and most objective medium with which to record it.

A professional photographer in Germany, Albert Renger-Patzsch was the leading exponent in photography of the New Objectivity, a wider movement in contemporary art which had begun in Germany with painters such as George Grosz and Otto Dix in reaction to the visual distortions of Expressionism. During the early part of the 20th century, representing the modern world and its technological advancements became the goal of the avant-garde. The emotion and sentiment of Romanticism did not match the rapidly moving world of glass and steel, aeroplanes, motor cars, factories and skyscrapers. Influenced by Cubism and Futurism in art, photographers had been experimenting with unusual views and angles, and distortions of lens and perspective as a means of expressing the modern technological world. The New Objectivity rejected this abstraction in favour of a cold, unemotional and objective realism. The idea was to present the world through the plain and uncompromising reality of objects as they actually exist.

The advantage that photography had over art was that the process itself was mechanical and therefore objective. Renger-Patzsch himself argued that it was the perfect medium to demonstrate this: 'The absolutely correct rendering of form, from the brightest highlight to the darkest shadow, imparts to a technically expert photograph the magic of experience. Let us therefore leave art to the artists and let us try to use the medium of photography, to create photographs that can endure because of their photographic qualities, without borrowing from art.'

To this end he used a large-format camera and sought to render his subject with perfect clarity. His vision had a tremendous influence on photographers. He set about making an objective study of the world of things, industrial subjects as well as natural ones in an attempt to show underlying similarities of form, showing how subjects that had never previously been considered worthy of attention could be used.

recreating the effect

This photograph proves that representation is in the hands of the photographer and that choosing what you decide to put in your frame and how you treat it determines how the picture is viewed. Renger-Patzsch has chosen his subject for its plainness and presented it to accentuate a straightforward reading of the stack of wood. He has used the strong side-light to highlight the square sides and show us the dimensions of the stack of wood. Use of a large-format camera was important to Renger-Patzsch to record as much detail and texture as possible, and so for a modern approach you would aim to frame the image with great care and use a tripod and slow film to get the sharpest image possible.

ALBERT RENGER-PATZSCH
(1897–1966)
Born in Wurzburg, Germany, the son of an amateur photographer, Renger-Patzsch began experimenting with photography as a teenager. After serving in World War I, he studied chemistry in Dresden and in 1920 took up the post of Head of the Photographic Archive at the publisher Folkwang-Verlag. He got his break as a photographer in 1924 providing images for two books in a series entitled *Die Welt der Pflanze* (the world of plants). He began working as a freelance documentary and press photographer in 1925 and is best known for his book *Die Welt ist schön* (*The World is Beautiful*), published in 1928 and for his contribution as the leading photographer of the Neue Sachlichkeit (new objectivity) movement in German art during the 1920s and 30s. He worked as a correspondent during World War II, towards the end of which his studio was bombed and he lost over 18,000 negatives. After the war he turned to landscape photography, which he concentrated on until his death in 1966.

paul caponigro

Backlit Sunflower, Winthrop, Massachusetts, 1965 gelatin silver print

behind the image

As beautiful as this picture is, its creation may have been an accident! Caponigro was using only backlighting to photograph the sunflower and apparently slightly miscalculated the exposure to create this wonderful image where everything is left in complete darkness except the semi-transparent petals and the tiny hairs on the stem, which are magically lit up and define the flower's shape. The light source must be directly behind the head of the flower and positioned in such a way that it is entirely hidden from the camera.

This is one of a series of images Caponigro took of sunflowers, during a period of several months in 1965 – a momentous time for the photographer, shortly after his son was born. He explored the flower in many different situations, from different angles and in different lighting conditions, from studies of a single flower like this to displays in public gardens. Best known as a landscape photographer, Caponigro's most famous image is of a herd of deer (*Running White Deer*), the blurred movement of the running animals giving them a ghost-like or spiritual quality. This romantic or ethereal effect is central to Caponigro's landscape work and the many pictures he took of ancient sites in England, such as Stonehenge, and Ireland are witness to this. On the face of it this sunflower picture is very different – a study photographed in a studio environment rather than out in the landscape, but Caponigro's poetic landscape pictures are an exploration of forms in nature, his stated purpose: 'trying to express and make visible the forces moving in and through nature'. The minute observation of the sunflower, the magical light and the revelation of the sunflower in this unexpected form are entirely consistent with this style.

Although Caponigro's images are often romantic and emotional in content, he is nevertheless a skilled technician of the photographic process and a revered teacher. A master in the darkroom, it is perhaps apt that one of his sunflower pictures was so popular that it was used for a time by Kodak as the illustration on boxes of its photographic paper.

PAUL CAPONIGRO
(1932–)
Born in Boston, Massachusetts, Caponigro became interested in photography while he was at high school. He was also a keen musician and studied at the Boston University College of Music from 1950 to 1951. In 1953 he turned to photography and attended the California School of Fine Art, later studying with Minor White. Best known for his sensitive images of Stonehenge and other ancient sites in Britain and Ireland, he is also a celebrated teacher, first taking up a post at Boston University in 1960, then at New York University in 1967 and Yale from 1970.

recreating the effect

An extremely tricky picture to recreate – in order to get the halo around the petals the sole light source must be hidden behind the sunflower. You could use an angle-poise lamp or a light held on a clamp – the base would be far enough behind the subject to be hidden by shadow. If you expose for the shadow detail of the sunflower you will not get that lovely halo effect around the edges of the flower. Essentially you are exposing for the bright light that surrounds the plant and letting the head of the flower stay in shadow. Almost impossible to meter, try a few frames at different exposures. It will probably require a lot less exposure than you think.

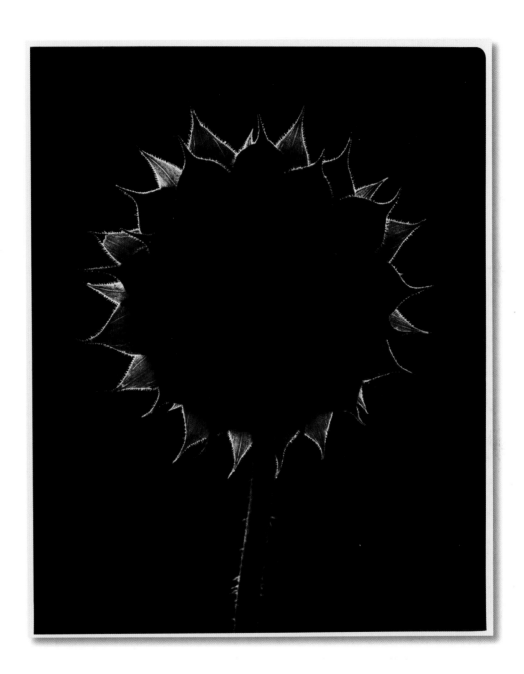

rudolf koppitz

Movement Study, 1926 *carbon print*

behind the image

This is one of the most famous and frequently published photographs in the history of photography, but despite world fame in the 1920s and 30s, its creator Rudolf Koppitz has otherwise been all but forgotten. The models for the photograph were dancers; the nude figure a Russian dancer called Claudia Issatchenko. Koppitz had connections at the Vienna State Opera Ballet, which is most likely how he came into contact with Issatchenko, who would only have been an infrequent visitor to Vienna where Koppitz was working at the time.

Koppitz was known to be an enthusiast of the contemporary vogue for physical vitality pursued through sport and healthy outdoor exercise. Therefore the title of 'movement study' might lead us to think that the photograph is a celebration of

physicality. But the highly controlled composition owes more to the influence of Symbolist artists such as Gustav Klimt whose work was to be found everywhere in Vienna at the turn of the century. In contrast to the purely picturesque and naturalistic style typified by the Impressionist painters of the late 19th century, Symbolism sought to infuse imagery with significance, using symbols and conventions to convey metaphorical and allegorical meaning. In Klimt's work women are often portrayed as the embodiment of sexuality and the flesh, in contrast to the intellect of man. They are temptation and ultimately man's downfall – the classic *femme fatale*.

The *Movement Study* took pride of place in Koppitz's own studio, but it was hung as the central panel in a triptych,

which perhaps gives a clue to its meaning. The other two photographs are of a mother and child and a Rodin-like 'thinker' seated in the landscape, entitled *In the Bosom of Nature*. Following the codes of Symbolist art, the mother and child must represent the beginning of the cycle of life while the thinker in nature is man at full intellectual maturity in the world of nature. The central panel must therefore be death.

RUDOLF KOPPITZ
(1884–1936)

Rudolf Koppitz was born into a poor family of weavers in Schreiberseifen (a village close to the town of Freudenthal) in the modern Czech Republic. Following an apprenticeship with a photographer in Freudenthal, he worked in various professional studios around Europe including the Carl Pietzner Studio – a portrait business with a number of studios throughout central Europe. Three years' military service were spent mostly in Vienna where he stayed afterwards and undertook several more jobs in commercial photographic studios. In 1912 he entered the Graphic Arts Institute in Vienna as an ordinary student and was taken on in a salaried post a year later. Able now to pursue his photography as an art rather than a profession and explore modern print processes at the college, he established himself as a leading Pictorialist, exhibiting throughout Europe and America from the mid-1920s until his death in 1936.

recreating the effect

There is a long history, in religious art in particular, of the use of symbols and allegory to convey meaning. Modern audiences on the whole do not have the knowledge at their fingertips to decipher these scenes but using symbols that do not necessarily need deciphering is applicable practically when taking portraits. At a simple level, the tools of someone's trade in a portrait can add information and meaning, or the inclusion of books or a pair of glasses might identify the sitter as intellectual. But this can be taken much further: surround your subject with objects that give clues as to their interests, tastes, history or family and it is possible to construct a portrait that will certainly have many layers of meaning, providing atmosphere and grounds for speculation for the viewer.

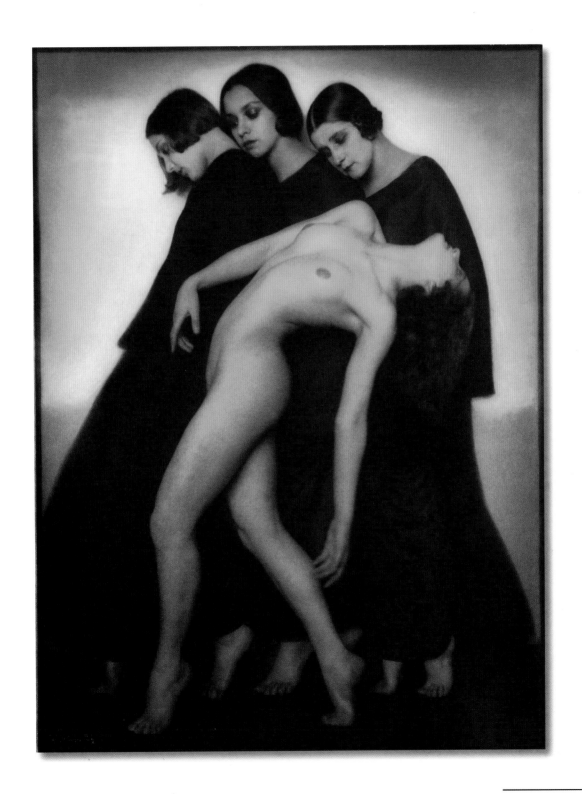

andré kertész

From My Window, _c._ 1980 polaroid print

behind the image

One of the great masters of 20th-century photography, Kertész's work is not easily categorized. He did not align himself with any particular movement or group of artists, or with photojournalism (though he was a huge influence on photographers such as Robert Capa and Henri Cartier-Bresson). Instead he drew on his personal life for his work and relied upon his own aesthetic.

This image is one of a long-running series taken from within Kertész's Fifth Avenue apartment in New York, part of which (unusually for Kertész in Polaroid colour) was published as a book in 1981. This image could perhaps be said to be reflective. Taken late in his career it deals not only with the fall of light and reflections but also includes a self-portrait (in shadow form) and one of the recurring themes of this series – the glass bust, which, according to Kertész, represents his wife of more than forty years, Elisabeth, who had died of cancer in 1977. The second bust, head inclined in relationship, must therefore represent Kertész himself.

The apartment window overlooked Washington Square, and Kertész photographed the passers-by and the architecture of neighbouring buildings, always playing with the shapes and lines of the rooftops, windows and terraces, accentuating the geometry. He was interested in balance of form rather than the subject itself and increasingly experimented with still life arrangements of glass and wooden objects placed on or near the window, from which he would record the arrangement of light and shadow and the play of reflections.

The simplicity of the project is characteristic of Kertész who hardly changed his methods throughout his career. He began using 35mm Leica cameras when they were introduced in Germany in the 1920s and was loyal to his basic equipment for the rest of his life, this late series of Polaroids being the only exception. He never had his own studio and the fact that he was able to produce a body of work of such variety like this without leaving his apartment is testament to his mastery of the medium.

recreating the effect

Kertész not only produced a great photograph but a whole body of work simply by pointing his camera out of the window and setting up fascinating objects in relation to it, looking for interesting shapes and angles, shadows and reflections. Clearly the lesson to be learnt from this is that if you have the skill you can find a good photograph wherever you look; the photograph is not necessarily about the actual nature of the subject but more the way in which you arrange elements within the frame. If you can, like Kertész, learn to see the world as a series of planes, angles, light and shadow, then there is an endless and ever-changing variety of subjects to photograph wherever you are and at any time of day.

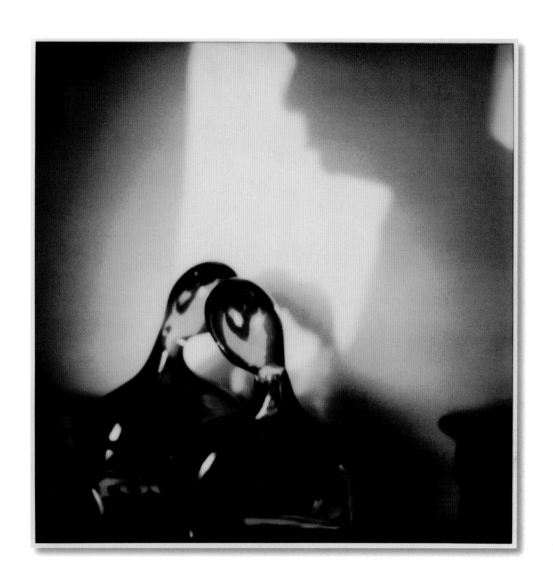

clarence h white

Nude, *c.* 1907 platinum print

behind the image

White was a master of light and form and this exquisite composition is testament to his virtuosity. Like many of his fellow Pictorialists he believed the photographer should intervene in the process so that they might create art rather than a mere mechanical reproduction. In White's case, he favoured the platinum process which allowed for very detailed rendering of tonality and he exploited the medium by creating images in pale, almost luminous tones. His pictures are characterized by this use of delicate light, often almost glowing from the highlights. None of his pictures have heavy shadows or dark tones. In this nude study he has created a porcelain luminosity in the skin tones, which is only matched by the white vase to the left of the image. This clever device plants in our mind the idea of the nude as a statuette, a decorative art object rather than a real human presence, and also reinforces the impression of her skin being as smooth and translucent as the vase.

This presentation of the nude as an idealized beauty not only fulfilled White's intentions for a decorative composition but would also have been sufficiently removed from the reality of naked flesh to satisfy public expectations of propriety at the time. The decorative nature of the photograph is very much in the style

CLARENCE HUDSON WHITE
(1871–1925)
Originally a bookkeeper from Ohio, White was a leading figure in the Pictorialist movement, a founding member of Alfred Stieglitz's Photo-Secession and also a member of the British Linked Ring. Only able to afford two film plates a week, he began making carefully prepared portraits of people in his home town of Newark, Ohio. After exhibiting his work and receiving encouragement from Stieglitz, he opened his own studio in Ohio in 1901; in 1907 he moved to New York, collaborating with Stieglitz who featured his photographs in *Camera Work*. At the same time he took up the first of a number of important teaching posts, at Columbia University. In 1910 White founded a photography summer school in Maine and in 1914 The Clarence H White School of Photography in New York City. Here he influenced a generation of American photographers who attended his courses including Margaret Bourke-White, Dorothea Lange and Paul Outerbridge.

of Art Nouveau. In White's photograph the relationship between the vase of flowers and the nude's arm is typical of the flavour of Art Nouveau, which was characterized by fluid plant forms and an overall unity and balance of design.

The model for the picture was a certain Miss Thompson who had been recommended to both White and Alfred Stieglitz, with whom he had been collaborating on a series of nude studies. Despite this collaboration, White's

tendency towards the decorative, evident in this photograph, led to them moving apart artistically as Stieglitz, who had founded the Photo-Secession and promoted American Pictorialism, increasingly moved towards the new 'straight' photography.

recreating the effect

Clarence H White is composing in two dimensions for his decorative effect. The vase in the foreground and the nude in the space beyond the door are drawn into the same plane, a flattening of perspective that can be achieved with a medium telephoto lens. The luminous quality of the model's skin is partly due to the photographer's skill in setting the exposure so that skin tones record as the palest highlights (though still with sufficient detail), but also inferred by association with the sensuous shape and texture of the vase. This is a clever technique that can be applied to many situations, subtly reinforcing a shape or texture by reference to another object within your picture frame.

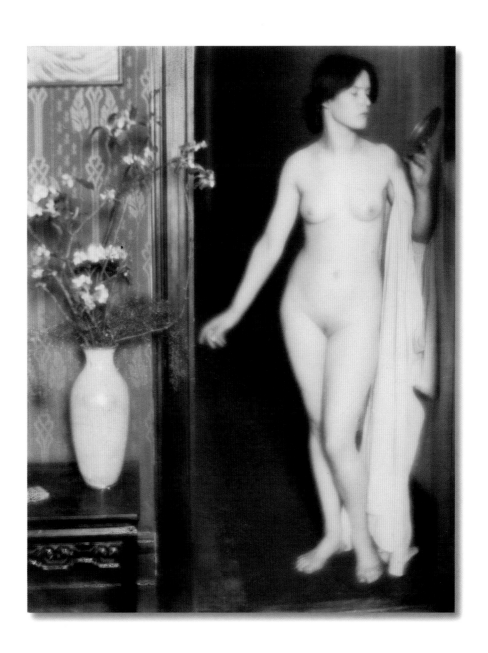

oscar rejlander

The Two Ways of Life, 1857 albumen print

behind the image

In this epic photograph, reminiscent of the great history paintings of the 18th and 19th centuries, a father stands under an arch with his two sons. The arch itself represents the threshold between two choices, or two ways of life. To the left of the picture – idleness, vanity, drunkenness and debauchery, and to the right – purity, piety and industry. The veiled nude in the centre of the picture is perhaps symbolic of the hope of forgiveness in repentance.

Oscar Rejlander's masterpiece of early photography is clearly attempting to create an art piece in the tradition of contemporary allegorical painting, and he certainly took pains to overcome the limitations of his medium to create his grand vision. No enlargement was possible at the time and in order to create the final image he needed to make a combination print of more than thirty negatives, which took him up to six weeks to complete.

He posed actors in his studio and photographed them one by one to a preconceived plan. He then prepared a negative for each section of his composition and painted out with black varnish those sections of each negative that he did not require. Each negative was then exposed in turn on to the sensitized printing paper, beginning with the foreground figures and moving to the background figures, using a sketch and a pair of compasses to determine the correct proportions. When the whole composition was complete, the paper was toned and fixed. In fact the size of *The Two Ways of Life* required two pieces of paper to accommodate the whole design.

An incredibly meticulous process, five prints are known to have been made by Rejlander, one of which was bought by

> ### OSCAR REJLANDER
> (1813–1875)
> Born in Sweden, Rejlander studied art in Rome and then set up as a portrait painter in Wolverhampton, England. In the early 1850s he turned to photography, making portraits and complex tableaux using circus girls, street children and prostitutes as his models. He developed a number of new processes, most notably combination printing which is exemplified by *The Two Ways of Life*, his best known work. He participated in the Paris Exhibition of 1855 and with a growing reputation, moved his studio to London around 1862. Further experimentation with double exposure, photomontage and retouching techniques, on which he lectured and published widely, established him as a leading expert in photographic technology. His prints were sold as drawing aids to leading painters of the day and in 1872 his photographs were used to illustrate Darwin's treatise on *The Expression of the Emotions in Man and Animals*.

Queen Victoria for Prince Albert at the Manchester Art Treasures Exhibition in 1857 where it was first exhibited. This no doubt went a long way towards endorsing the legitimacy of what was at the time a controversial image; indeed the Scottish Society, who were due to exhibit the photograph, initially refused because of the nudity, but apparently relented the following year, agreeing to display it with one half curtained off!

recreating the effect

Morality tales and allegory do not have much place in modern photography, certainly not in such a literal way, but making a montage of many different images is so much more easily done today (particularly using layers in Photoshop) that as a style, it is cropping up more and more. However, unlike the montages of today's celebrities and socialites that appear in the press, Rejlander planned and photographed each element of *The Two Ways of Life* before assembling the final composition. Like a film director he storyboarded his image and then shot each individual part. This is an idea that could provide a fascinating project: planning and photographing to order a grand composition that could not otherwise be achieved. It would then be considerably easier – and quicker – to pull together than Rejlander's original.

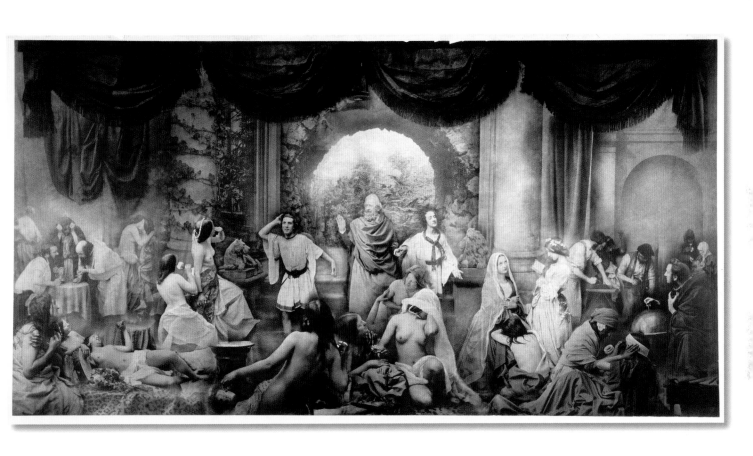

brassaï

Les Gouttes, *c.* 1935, gelatin silver print

behind the image

The water droplets in this (almost) abstract study put one in mind of Man Ray's famous photograph, *Glass Tears* – a close-up of a pair of beautiful eyes crying perfect tears. It appears, judging by the flawless spheres and crystal-clear reflections, that Brassaï has also used glass to get the hyper-real effect of the water droplets in his image.

Best known for his haunting, evocative photographs of Paris by night, Brassaï is associated with the Surrealist movement, principally through his work on the Surrealist magazine *Minotaure*. The magazine was run by the poet André Breton who, deeply influenced by the discoveries of psychoanalysts Sigmund Freud and Carl Jung, had founded the Surrealist movement in the 1920s. He and

his followers sought to find ways of expressing the subconscious world of Freud and Jung, without any particular attempt to organize it so that it would 'make sense' in reality. Hence the fantastical and nonsensical paintings of artists such as Salvador Dali and René Magritte.

Brassaï had originally wanted to be an artist and was immersed in the art community in Paris, forging important friendships with leading figures such as Pablo Picasso. His first contributions to *Minotaure* were in fact his photographs of Picasso's sculpture, and the association with the magazine led to further contacts with important artists including Man Ray.

But despite these strong associations, Brassaï made a clear distinction between

BRASSAÏ
(1899–1984)
Taking his name from the town of Brasso (in present-day Romania) Gyula Halász studied art in his native Hungary and came to Paris in 1924 as a journalist. Initially trying to capture Paris nightlife with paintings, his compatriot André Kertész persuaded him to try photography. He quickly became devoted to the medium and published a book of his pictures *Paris de Nuit* in 1933. It was in Paris that he came into contact with many leading artists and writers with whom he had lifelong associations; in 1964 he published a successful book *Conversations avec Picasso* with his friend and contemporary Pablo Picasso. He travelled in France and Spain but continued to document the people and places of Paris, turning his camera on its graffiti in the 1950s.

his work and Surrealism: 'The surrealism of my images was nothing more than reality rendered fantastic by vision. I sought only to express reality for nothing is more surreal. If we no longer marvel at it, that's because habit has made it seem banal. My ambition was always to show some aspect of everyday life as though we were discovering it for the first time.'

This is exactly what he achieves in this image by the simple method of using an extreme close-up and enlarging the subject beyond the proportions we are used to seeing.

recreating the effect

When photographing flowers and plants, and in food photography, drops of water add a feeling of life and freshness. A studio photographer's trick for photographing water droplets is to use glycerine or glycerine mixed with water, which can then be more easily placed and won't evaporate quickly under lights. But Brassaï's stated approach of revealing hidden aspects of everyday life is showing us that any small detail can make a worthy subject for photography. The mundane is routinely ignored and so to draw attention to texture and detail can lead people to discover it as if for the first time. Details of buildings, mechanical structures, close-ups in nature, even the street beneath your feet, if carefully framed, can produce worthwhile and stimulating images.

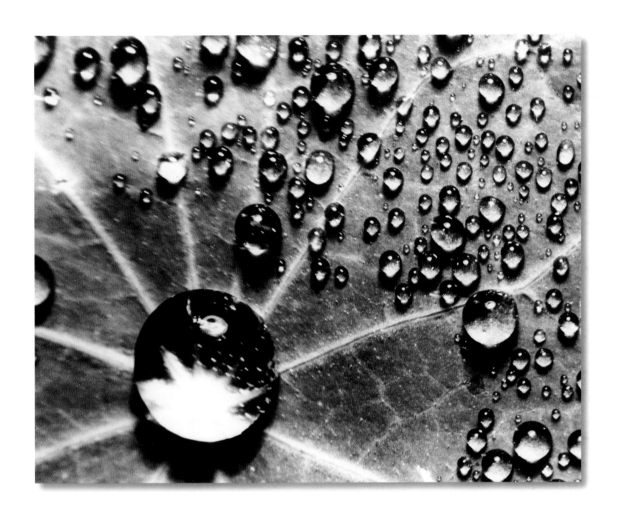

emma barton

Old Familiar Flowers, 1919 autochrome

behind the image

This decorative composition of the photographer's daughter Hilda is reminiscent of a style that Emma Barton had pursued with great success in the years before World War I. Experimenting with the relatively new autochrome process here, she is revisiting old themes in a picturesque style, at a time when more progressive photographers (particularly those involved with the new 'straight photography' in America) were taking the art in a very different direction.

The autochrome colour process had been invented by the Lumière brothers in 1907 and produced a distinctive grainy colour image. It was far from practical, long exposures being required and the eventual image needing to be seen through a viewer. However, in the hands of practitioners with the time, money and expertise, spectacular results were possible. Emma Barton has arranged her colours to make the most of the three-colour process, dressing her model in a blue dress, setting her amidst the greenery and adding the touch of red (or the distinctive autochrome orange-red) with the gnomes' hats.

While she is little known today, Barton had been a leading figure in the early part of the century, mainly in the field of portraiture in the Pictorial style. She sought to create images that combined 'a picture and a portrait', something beyond the stiff formality of the portraits of the day. Although comfortably wealthy (despite her lowly birth in Birmingham) and able to afford to experiment with an expensive process like autochrome, generally her methods were rudimentary. According to a contemporary she had 'no elaborate darkroom or mechanical equipment' and was known to prop her camera on a chair and a pile of books instead of using a tripod. She had no studio and posed her photographs in any corner of her home or garden that suited her purpose, often dressing her sitters in costumes that she had made herself.

Although no longer at the vanguard of contemporary photography, this is a fascinating example of early colour, but in a style which at the time was rapidly falling out of favour. In her later years, Emma Barton withdrew from exhibiting her work altogether and in this image of her daughter we see the theme that would occupy her private photography for the rest of her life: her family.

EMMA BARTON
(1872–1938)
Emma Boaz Rayson was born into a working class family in Birmingham and, as a teenager, introduced to photography by her stepfather. A (common law) marriage to a Birmingham solicitor (George Barton) moved her up the social ladder and a family connection allowed her to take a series of portraits of the popular music hall star, Dan Leno, which became her first published photographs in 1898. Exhibiting pictures of religious subjects and portraits she was awarded the Royal Photographic Society Medal in 1903. The following year she was given her own exhibition and her photographs began to be widely exhibited internationally. Turning to subjects based on Old Master paintings during the later 1900s her work showed the influence of the Arts and Crafts movement and the Pre-Raphaelites. After World War I she increasingly photographed her own family; in 1932 she retired to the Isle of Wight.

recreating the effect

With modern photographic equipment it is almost as novel to take black-and-white pictures as it was for Barton to take colour. We tend to take colour for granted now, but arranging and balancing colours within the frame (and deliberately placing them) can have as dramatic an effect as graphic compositional lines. It would also be possible in Photoshop to recreate some of the properties of autochrome, adding 'noise' or using a filter to get the grainy effect, and adjusting the colours to imitate the distinctive soft shades.

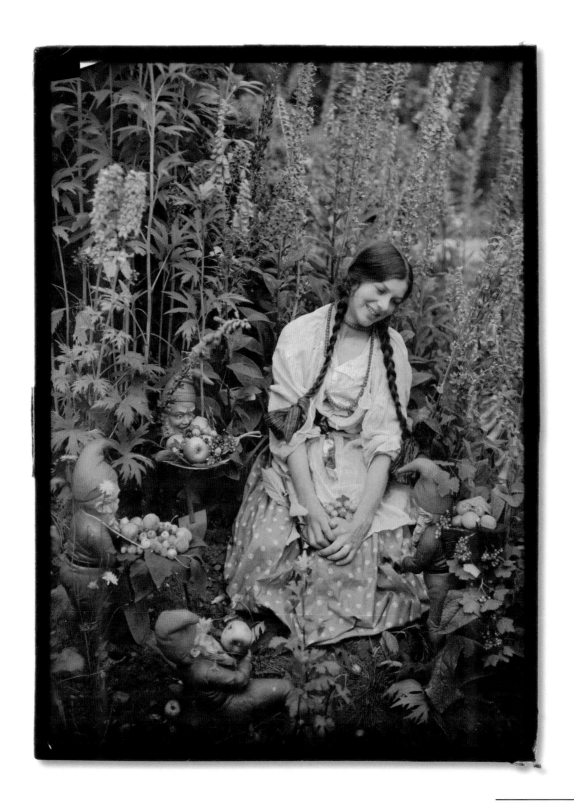

henry peach robinson

Bringing Home the May, 1862 albumen print

behind the image

This spectacular scene is the most ambitious photograph Henry Peach Robinson ever attempted and certainly his most famous. Impossible at the time to create such an image by any other means than manually splicing together several negatives, *Bringing Home the May* measures a massive 40x15in and is made up of nine separate negatives. Robinson is particularly remembered for perfecting the technique of combination printing (making a print from several negatives), which he more than likely learnt from his friend Oscar Rejlander.

Robinson was a pioneer of Pictorialist photography, intervening in the photographic process to create something more painterly than merely an accurate record of a subject; Robinson and his followers wanted photography to be considered less a scientific tool, more an art to rival painting. *Bringing Home the May* is testimony to a level of craftsmanship to which photographers of the time aspired in order to be recognized as artists. Don't forget at this time there was no enlarging of negatives; everything was done from contact prints. If you examine one of his 'join-ups' closely you can see where the contact prints come together and there are often patches of grey, with no detail there at all. Skies were always a great problem and he kept many exposures of skies in readiness to match up with other prints when required.

Robinson was heavily influenced by the work of the Pre-Raphaelite brotherhood of painters such as John Everett Millais and Dante Gabriel Rossetti, and his choice of scene for this tableau reflects this, showing

HENRY PEACH ROBINSON
(1830–1901)

Robinson was originally a painter and had an oil painting exhibited at the Royal Academy of Art in 1852, but he started experimenting with photography and in 1857 he committed to the medium, abandoning his career as a bookseller and opening his own portrait studio in Leamington Spa, England. Constrained by the limitations of photography he pioneered combination printing, using several negatives to produce photographic compositions that rivalled paintings as 'art'. For 30 years Robinson was on the Council of the Photographic Society but eventually left to form the influential Brotherhood of the Linked Ring to promote the concept of photography as art.

a romantic rural idyll in an idealized neo-medieval setting. The inspiration for the composition came from a verse celebrating May by the 16th-century English poet, Edmund Spenser.

Robinson achieved his aims to some extent when the picture was shown in 1862 at the Photographic Society annual exhibition, and was met with great praise from the photographic press, highly acclaimed as an outstanding technical and aesthetic achievement.

recreating the effect

Creating joiners has never been as easy as it is today. The computer makes it a much simpler job to seamlessly match different photographs. Alternatively prints can be overlaid and retouched to get rid of the evidence of any joining, then photographed as a single piece, making one negative from which hundreds of perfect prints can be produced. However, to create a scene like Robinson's takes more than the ability to join together several images; it's more about planning and executing a highly complex composition akin to an epic painting. Attempting to recreate such a painting photographically would be a good place to start. The flexibility of digital images and Photoshop has made montages much more common, and fascinating effects can be achieved by building up apparently continuous scenes from many different images of the same place or event.

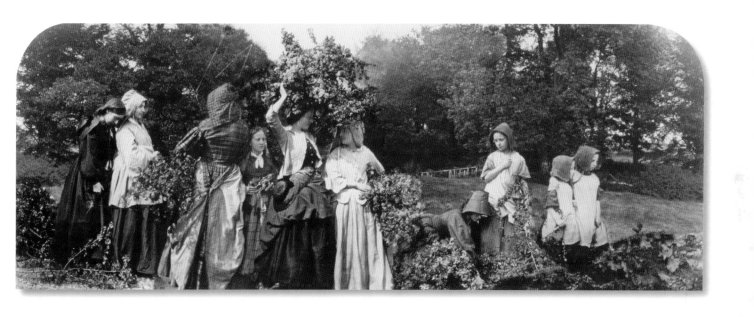

manuel alvarez bravo

Optic Parable, 1931 platinum print

behind the image

The first thing you notice about this famous image is that it is the wrong way round, or flipped. But this is how Bravo chose to print it. It is reputed to have originally been a printer's mistake that he decided to stick with, but it's equally plausible that it was his intention from the beginning, so in keeping is it with the nature of the image.

The *Optic Parable* is a game or a play on the nature of seeing. At one level it is a straight photograph presenting us with an accurate representation of a real shop front (albeit reversed). But the angle from which Bravo has chosen to frame it is the first subversion; it is not from natural eye height, but angled and from beneath, presenting things not as we are used to seeing them (particularly at the time, when such unusual angles were quite avant-garde). The shop itself is an optician's, a specialist in human sight and lenses that correct (or alter) perception. The disembodied eyes looking from the windows and the surreal, all-seeing eye on the shop sign are all reflected in the glass so it is not clear to what the eyes belong and which are the reflections and which the painted signs.

The fact that the image is reversed is

MANUEL ALVAREZ BRAVO
(1902–2002)
Born in Mexico City, Bravo began work as a clerk at the Mexican treasury department, studying the arts in the evening. He became interested in photography when he was 20 and in 1926 won a major prize for his work at an exhibition in Oaxaca. The following year he met American photographer Tina Modotti who greatly encouraged his work. Establishing his reputation, he became the most significant photographer in Mexico at a time of cultural renaissance and was in contact with leading artists such as Diego Rivera, and through them important figures in the art world beyond Mexico. During the 1940s and 1950s he worked in the Mexican film industry and taught photography at the Film Institute in Mexico City, returning to his personal photographic work in the 1960s. He continued to live and work in Mexico City for the rest of his life.

recreating the effect

Although Bravo's photograph is packed with clever content, it is nevertheless constructed from an existing shop front, making use of the different planes of glass and the many reflections visible. It can be easy to mentally overlook shadows or reflections while focused on a more tangible subject, but they can be the source of great pictures themselves.

Photographing the glass of shop fronts as in Bravo's image it is possible to create fascinating and complex, almost cubist images, merging the objects or people inside with the reflections of the street. Modern cities invariably have buildings that are literally walls of glass which can be the source of amazing architectural pictures reflecting the sky or surrounding buildings. And of course water is a great reflector in landscape photographs, in particular the still water of lakes or pools, which can be used to spectacular effect to create a mirror image of the landscape beyond.

the final quip in the satire of optical oddities: all lenses, including our eyes, create a reversed image which our eyes or the printer then unscrambles, so it is entirely fitting in this surreal world that it should be mirrored, forcing us to attempt to read the lettering backwards. Once we do, this thoroughly modern image is capped by the apt name of the shop: Optica Moderna.

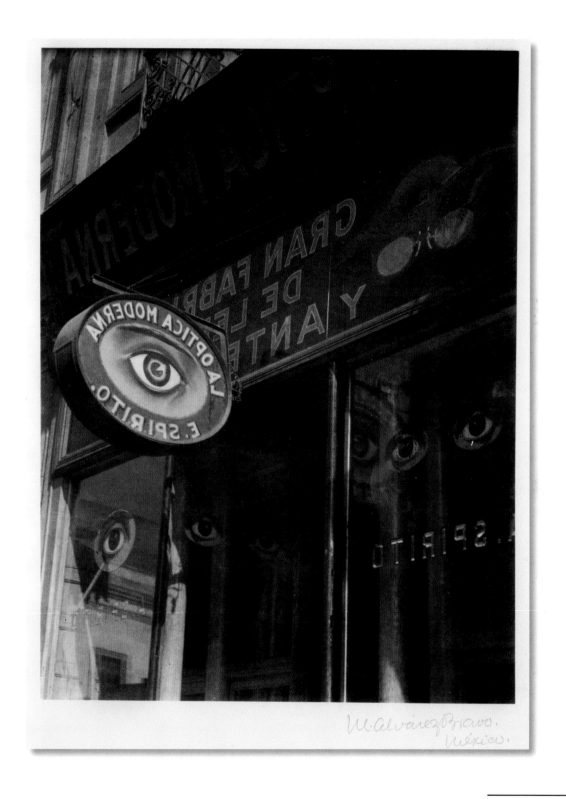

portrait
photography

julia margaret cameron

Iago, Study from an Italian, 1867 albumen print

behind the image

Julia Margaret Cameron was undoubtedly the leading photographic portraitist of her day. In an age when the difficulty of the photographic process usually made for stilted and formal images, she was able to move beyond that and portray a depth of personality in her sitters. This portrait is incredibly modern in appearance; with the unkempt hair and casual costume, the man hardly seems Victorian and could easily be a modern film star. The sitter is actually an Italian model called Alessandro Colorossi and this picture is the only known example of Cameron using a professional model. The situation may have come about as a result of Cameron's association with her neighbour – the poet Alfred Lord Tennyson. He was a friend of many leading figures of the day including the painter George Frederic Watts who was also known to have used Colorossi.

Cameron's portraits are essentially life-size and this contributes greatly to their powerful effect. An already large format camera (9x11in) was not enough for her and around 1865 she changed to an enormous 11x15in negative size. Needless to say the size and quality of the print was impressive in an age when enlargements could not be made. The nature of the equipment and Cameron's demanding

standards made for very long exposure times which must have been awkward and uncomfortable for the sitter. In that respect the model's professionalism in this case must have contributed to the success of the picture.

Iago looks down and not at us, and it is this that begins to make us wonder what he is thinking. The light is coming from above and slightly to the side accentuating the modelling of his cheekbones on both sides and the downward cast of his eyes. He does not look especially evil to us now and whether the portrait was planned as a representation of Shakespeare's villain or the artist imposed this title later is not known.

JULIA MARGARET CAMERON
(1815–1879)
Born in India to an affluent British family, Julia Margaret Cameron was educated in England and France, but went back to the east and settled in Ceylon (Sri Lanka) after marrying Charles Hay Cameron. Returning to England in 1848, she did not take up photography until, at the age of 48, she was given a camera by her daughters. She photographed tirelessly for the next 12 years until she returned to Ceylon in 1875. Her subject matter was always romantic portrayals of literary or religious characters, influenced by the Pre-Raphaelite painters of the day, as well as portraits of friends, family and servants including many of the most notable contemporary figures including Charles Darwin and Lord Tennyson.

recreating the effect

To obtain a life-size print these days does not require the enormous camera and negative size that Cameron was working with, as any negative can be enlarged to make a print, however big you want it. Obviously the better quality image you start with the better your enlargement will be – a larger format will be an advantage, and try to use slow film to minimize any grain that might become visible with a big enlargement. Expressing the personality, psychology or emotion in a portrait is much more difficult, but the pose and expression of your sitter can have a significant effect: getting your subject to look up or down at the camera, fold their arms, tip their head, face the camera square on, or turn to the side all have subtle effects on how they come across in the photograph.

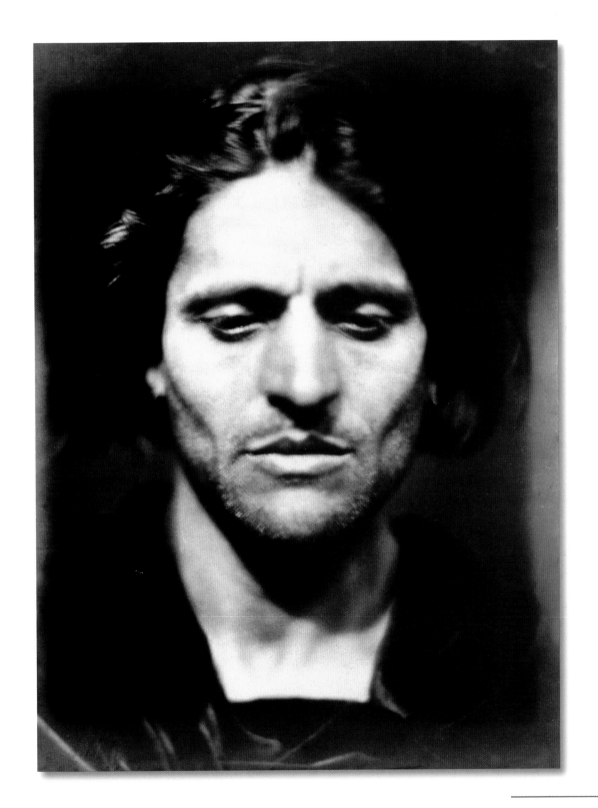

nickolas muray

Soldiers of the Sky, 1940 3-colour carbro print

behind the image

This image of a rather glamorous female aviator is clearly intended to spur the American people (and particularly its women) into patriotic and martial pride as all were encouraged to do their bit in the forthcoming war effort. The beauty of the model and meticulous make-up, especially the red lipstick, vividly described by Muray's colour process, avoids any echo of dour Fascist or Communist-style propaganda images. Belonging to the world of the fashion magazine rather than propaganda poster, this heroine is all-American. Unlike the 'hero-archetypes' of totalitarian regimes, she stands for freedom of choice and independence as she shields her eyes from the bright sunshine, or perhaps the dazzling might of the United States Air Force.

Nickolas Muray inaugurated a new era for his trade in 1931 when the June issue of *Ladies' Home Journal* reproduced two of his colour photographs of beachwear, in what were the first magazine reproductions to be made from original colour prints. Muray's work was astoundingly vivid, almost three-dimensional and, because of the carbro process he used, permanent. The word carbro derives from carbon and bromide and the process works by chemical, rather than light sensitization and was used to stop silver-based prints fading. The basic idea is to produce a copy of a print by using something to colour it more permanently. This can be carbon for black-and-white, or dyes for colour prints. The prints produced are as permanent as the dyes used and have a sculptured surface that catches the light.

Muray's image is probably an amalgam of two negatives, one of the planes shot at an air show and the other of the model shielding her eyes from an apparently powerful sun, actually created in studio-controlled circumstances.

NICKOLAS MURAY
(1892–1965)

At age 12, Hungarian-born Nickolas Muray enrolled in graphic arts school, where he learned lithography, photo-engraving and photography. After graduation he took a course in colour photography, learning how to make colour filters. Moving to New York in 1913, he went to work for the publisher Condé Nast but by 1920 had opened up his own photographic studio in Greenwich Village. He established himself as a commercial photographer, in particular shooting a lot of food pictures, and went on to become a celebrated portrait and advertising photographer. Taking over 10,000 portraits between 1910 and 1920 for magazines such as *Vogue*, *Vanity Fair* and *Harper's Bazaar*, he photographed presidents, theatre and dance stars and other well-known members of society, and was one of the most famous celebrity portraitists of the day.

recreating the effect

Montaging two photographs is simply done today, especially in such circumstances where the model can be photographed against a white background and would be easy to isolate and cut out in Photoshop. Muray would probably have used a three-light set-up to photograph the model: one to create the harsh shadow across her face, a second to fill in light on her face and a third to light the background, allowing him to replace it later. The colours could be boosted in Photoshop and printed on archival paper to give that vivid technicolour carbro look.

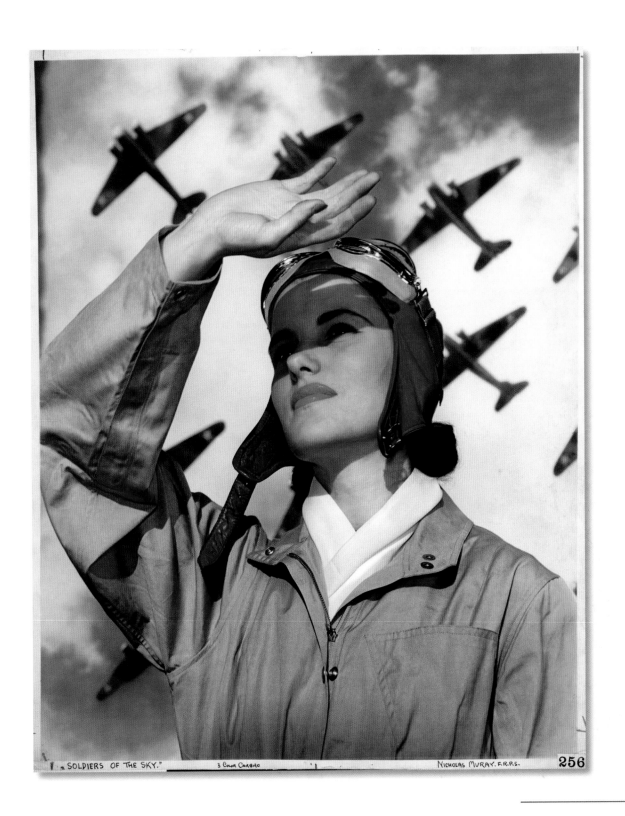

"SOLDIERS OF THE SKY." 3 Color Carbro Nicholas Muray. F.R.P.S. 256

lewis carroll

Xie Kitchin as a Chinese Tea Merchant, *c.* 1867 albumen print

behind the image

There is an unmistakable sense of personality in this image. Far from the stilted and formal portraits associated with the Victorian era, it conveys a fleeting moment, and as a result there is something modern-feeling about it – we can imagine what this girl might be like. In an age when exposure times ran into minutes, it is hardly surprising that the prevailing style was stiff and formal but Carroll manages to bring his subjects to life and this is never clearer than here, where the casual pose and the playful, but perhaps sulky, expression of the girl seems to give us a real glimpse of her personality, and despite the fanciful costume feels very natural.

Lewis Carroll is actually the name that Charles Lutwidge Dodgson chose for his writing career; he is best known of course as the author of *Alice's Adventures in Wonderland* and other children's stories, but he was also a prolific author on mathematical subjects. Photography was his hobby but one in which he was highly accomplished, and he made a speciality of photographing children, including Alice Liddell, the model for his literary character, of whom there are many portraits. Liddell was the daughter of one of Caroll's friends and fellow clergymen, as was the model for this photograph, Alexandra (or Xie – pronounced 'ecksie') Kitchin who was the daughter of the Dean of Winchester. Xie was one of Dodgson's favourite models whom he photographed many times from about 1868 when she was four years old.

LEWIS CARROLL
(1832–1898)
Born the eldest of 11 children, Charles Lutwidge Dodgson is better known for his celebrated childrens' stories, *Alice's Adventures in Wonderland* and *Through The Looking Glass*. Educated at Rugby School and Christ Church College, Oxford, Dodgson remained in Oxford lecturing and writing on mathematics, and took holy orders in 1861. Photography became his hobby and he made a number of portraits of some of the leading people of the day such as Lord Tennyson, Christina Rossetti and the painter Holman Hunt and had some of his prints exhibited at the annual exhibition of the Photographic Society in London. He was particularly interested in photographing children, one of whom, the daughter of the Dean of his college was the inspiration for his Alice stories. He published a number of scientific and mathematical works as well as more children's literature, notably *The Hunting of the Snark*, and despite buying a large home for his family, continued to live in his college until his death in 1898.

recreating the effect

You can have great fun dressing up and creating imaginary worlds with photography; you only need to control the space in your picture frame and you can suggest a whole environment. Just as you can create a perfect white space with a simple backdrop, you can find or hire props of just about any period or design to create an imaginary world. Clothes can have a powerful effect on how a portrait is perceived – the nature of dress is a clue to personality and showing the subject's bare feet, as Dodgson has done here, immediately implies informality. Likewise props give people something to interact with and help to put them at their ease when facing the camera. I often ask people if they have a favourite hat or coat when I am making portraits of them. I find it helps them to feel comfortable during the process and also, hopefully, brings out something of their personality.

This photograph was taken in the purpose-built studio Dodgson had made on the roof of his rooms at Christ Church College, Oxford. Dressing up as a Chinese tea merchant and using the richly patterned costume and tea chests is consistent with the Victorian taste for the oriental and exotic and also allows for a playful and relaxed portrait. The child's bare feet add intimacy and informality and the idea of the dressing-up box brings fun and spontaneity to the picture.

cecil beaton

Twiggy at 8 Pelham Place, London, 1967 c-type print

behind the image

Beaton has used the interior of this beautiful London house to make Twiggy an architectural feature herself. He accentuates her diminutive size and fragility by placing her on a pedestal, making a model out of his model. This is all the more potent as Twiggy was so famously tiny. She appears like a doll or an extension of the pedestal.

Equally well known as a stage designer, Beaton's photographs often display a theatrical quality. He always provided some sort of set on which to place his subject, whether it was elaborately constructed or on location like this. One of the first fashion photographers to take his models out of the studio, the fixtures and fittings become the set and props in Beaton's design.

Photographed in 1967, this is one of a set of pictures featuring the clothes of Foale and Tuffin, leading British fashion designers of the day. The location, 8 Pelham Place, was Beaton's own house in South Kensington, London, and the red and gold of the interior set against the vivid orange of Twiggy's dress creates an atmosphere of opulence and style; the striking colour combination is very much in tune with the times. The door and window frames are key to Beaton's composition:

the top of the pedestal, the light switch and the corners of the two frames all at different heights, in combination with the model, are held in perfect balance.

He has lit this picture predominantly from the left-hand side, as if trying to create the feel of natural window light. However, the secondary shadow confirms the use of a great deal of controlled light in the room. Never very happy setting up his own lights, Beaton was at his best when others took over the technicalities and left him to frame the image in his favourite camera, a 2¼in Rolleiflex, with which he was often photographed along with his trademark straw hat.

CECIL BEATON
(1904–1980)
Educated at Harrow School and Cambridge University, the well-bred Beaton first became known as a photographer in the late 1920s having established his own London studio. Moving to America he worked exclusively for *Vogue* during the 1930s, photographing many of the leading figures of the decade in Hollywood and New York. On his return to London he became the official royal photographer but a posting to the Ministry of Information during World War II influenced a change to a looser, less formal style. As well as his refined portrait and fashion photography he was also a celebrated theatrical costume and set designer, most notably winning two Oscars for his work on the films *Gigi* in 1957 and *My Fair Lady* in 1964.

recreating the effect

Beaton has deliberately used his location as a foil for the model, setting up the long, thin Twiggy on a column to draw attention to her shape. Finding good locations is a vital part of fashion photography, second only to finding the perfect model. Of course there are model agencies as well as agents who will search out locations. But use your imagination and good locations are everywhere, from crumbling old warehouses, an old lift or a tube station to the steps and columns of monumental architecture; there's something to be found in every town or city. Beaton's staged style has as much to do with the meticulous design and framing of his images as the use of location, sets and props. Take the light switch away from this image and it upsets the balance. No detail is too small to be overlooked when composing such a portrait.

fred holland day

Ebony, *c.* 1897 platinum print

behind the image

This remarkable photograph was not of Fred Holland Day's black employee Alfred Tanneyhill as had been thought, but of a model hired to pose for him. The model is not identified as any particular person but is represented as an archetype, and perhaps this helps to give the image its timelessness. Holland Day made many images in his career illustrating stories or myths; his intention was to downplay the role of the subject or sitter in favour of creating something more universal and lasting in line with the Pictorialist aim of presenting photography as fine art. The title gives us a further indication of this attitude, alluding as it does to the arrangement of tones rather than to the person of the sitter, rather in the style of Holland Day's contemporary, the artist Whistler.

Day was indeed influenced by the artistic movements of the day and his work is nostalgic for a pre-industrial era in a similar way to the Pre-Raphaelites and the Arts and Crafts movement in England. He wanted to promote the idea of a noble and simple tribal culture (hence his fascination with black males whom he dressed in African-style costume) as opposed to what he perceived to be the corruption of a mechanized and homogenized white civilization.

Fred Holland Day was a flamboyant character, dressing and acting like a dandy, often wearing cloaks and large floppy hats. He enjoyed a sense of drama and cast himself in his construction *The Seven Last Words of Christ,* growing his hair long and starving himself for the part of Christ. Religious or mythological subjects chimed with the concerns of artistic circles of the late 19th century, but Day's real fascination was with the male body and often depicted frontal nudity which, not surprisingly, met with considerable opposition at the time.

Always in pursuit of the highest quality in everything he was involved in, Day was a devotee of printing on platinum paper which gave very fine and subtle results but was naturally expensive. Russia was a major supplier of platinum, so the paper became very difficult to come by after the Russian Revolution in 1917 and Day's interest in photography consequently suffered because he was unhappy with other processes.

FRED HOLLAND DAY
(1864–1933)

Fred Holland Day was born the only son of a wealthy merchant near Boston, Massachusetts. An intellectual and aesthete, he forged connections with leading artists such as Aubrey Beardsley and Oscar Wilde, initially through his own fine art publishing house, Copeland and Day. His photographic work caused considerable controversy for its depiction of religious subject matter and male nudity but he became the leading spokesman for the cause of art photography and organized an important exhibition of 'The New School of American Photography' at the Royal Photographic Society in London in 1900. Day's influence in photographic circles waned as his rival Alfred Stieglitz rose to prominence, and a fire in 1904 tragically destroyed most of his prints and negatives. Eventually giving up photography altogether, he became increasingly reclusive, seldom leaving the family house in Norwood, Massachusetts that he had extensively remodelled in the Art and Crafts style in the 1890s.

recreating the effect

So modern-looking is this portrait, that it might very well have been taken today. A classic studio portrait, it could be achieved with a single light or electronic flash giving illumination from the left-hand side of the face. Black skin always needs extra exposure time, so I would allow at least one stop for the very dark skin and make sure that the background is not illuminated so it will naturally fall away to featureless black.

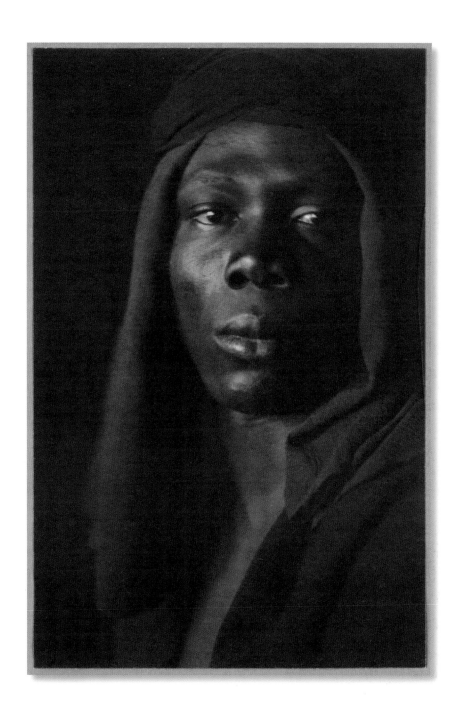

horst p horst

Carmen, New York, 1946 platinum print

behind the image

Horst took over as the head of *Vogue*'s Paris studio from George Hoyningen-Huene who had pioneered a new, sophisticated and elegant vision of fashion dedicated to the promotion of a perfect beauty, taking Grecian sculpture as a model of the ideal. Horst took up these ideas but developed a distinctive and personal style, particularly with his lighting, using strong and dramatic directional light, often from the top or behind his models.

This photograph was shot for *Vogue* in June 1946 and shows the newly discovered teenage model Carmen Dell'Orefice. Horst was particularly drawn to the 15-year-old's eyes: '...her almond-shaped eyes are those of a Renaissance beauty...she is an American beauty of an antique other age'. The unusual composition he constructed directs all

attention towards this remarkable face.

Horst had studied with the architect Le Corbusier and would have been well aware of contemporary trends in art and design. He helped to bring a new aesthetic to fashion and beauty photography which owes much to the developments in art of the period, in particular Surrealism – creating images beyond the 'real', images that were inspired by the world of the subconscious imagination.

Horst has fragmented his model into ambiguous and apparently unrelated body parts. Her head seems to be attached to an armless torso and a pair of hands float in space as they massage her face.

This photograph as a promotion of beauty demonstrates a new level of sophistication, one that relies on subtle psychological signals, to be understood

by an increasingly visually literate audience. Our attention is drawn to her porcelain complexion by the disembodied hands, and Horst juxtaposes her face with the draped fabric making a subconscious link between the textures. There is a feeling of luxury and extravagance, of smoothness and perfection.

HORST P HORST
(1906–1999)
Born Horst Paul Albert Bohrmann in Weissenfels-an-der-Saale, Germany, Horst studied at the Hamburg Kunstgewerbeschule and afterwards in Paris under the architect Le Corbusier. In 1930 he met the *Vogue* photographer Hoyningen-Huene who introduced him to Cecil Beaton, at that time working for British *Vogue*. Horst started photographing for the French edition of *Vogue* in 1931 and an exhibition of his work the following year brought him to wider prominence. He began to photograph leading celebrities of the day, including Marlene Dietrich, Salvador Dali and the Duke and Duchess of Windsor, and in New York in 1937 he met Coco Chanel and started a long association photographing her fashions. Taking American citizenship, he served as a US Army photographer from 1943–45 and returned to work in New York with *Vogue* and later *House and Garden* magazine. From the 1960s until almost the end of his life he travelled extensively, photographing high society lifestyles.

recreating the effect

This is a highly controlled studio image. Horst has strongly lit it from the side (note the shadows cast by the hands) and from the front, creating clean and even illumination across the model's face and the white sheet. The striking allure of the image is created by the ambiguity of her pose and the unusual composition, with the model's head so high in the picture space, drawing our attention to the expanse of white fabric occupying most of the frame. Photography manuals will often give compositional rules to stick to, counselling against this sort of thing, but framed with care, a deliberately unusual or even apparently unbalanced composition can have a striking effect.

yousuf karsh

George Bernard Shaw, 1943 gelatin silver print

behind the image

In 1931 Yousuf Karsh, already an accomplished photographer with a studio in Ottawa, joined the Ottawa Little Theatre where he worked with stage lighting and realized the effects that could be achieved. 'Moods could be created, selected, modified, intensified. I was thrilled by this means of expression…a new world was opened to me.'

Karsh applied what he had learned in the theatre to his portraiture, creating elaborate and complex lighting schemes. His success led to many opportunities to photograph dignitaries visiting Ottawa and thus build his reputation as one of the world's leading portraitists. Over the following decades he made portraits of many of the significant figures of the age including this image of the Irish dramatist George Bernard Shaw on a trip to London in 1943.

Bringing his extensive kit with him (an 8x10in view camera and many studio lights), Karsh set about creating his complex lighting scheme, picking out every nuance in Shaw's features and creating the almost painterly effect of the portrait. The result feels highly staged with Shaw dressed in a tweed suit to indicate his Irishness and attention is drawn to his glasses as a symbol of intellect. The main light source would have been directed on Shaw's face, another on the glasses and another picking out the arm of the chair which leads the eye up through the picture. A further light behind Shaw picks out the line of his shoulder and creates a gentle halo around the figure fading to black towards the edge of the frame.

Shaw himself was a very keen (but not very talented) amateur photographer and was not afraid to tell other photographers

YOUSUF KARSH
(1908–2002)
A refugee from Armenia, the 16-year-old Karsh was sent to live with his photographer uncle George Nakash in Quebec, Canada. Seeing potential in his nephew, Nakash sent him to Boston in 1928 to be an apprentice to studio photographer John Garo. Karsh returned to Ottawa to set up his own portrait studio in 1931; he became interested in theatrical lighting and began to develop the mastery of studio lighting that came to characterize his portraits. Befriended by the then Canadian Prime Minister, Mackenzie King, Karsh was given the opportunity to photograph prominent figures visiting Canada and his reputation was made by his portrait of Winston Churchill, taken in 1941. He went on to photograph many of the most significant people of the 20th century including Albert Einstein, John F Kennedy and Pablo Picasso.

what he thought of their efforts. However, it was on the subject of Karsh's nationality that the photographer felt the force of Shaw's tongue when they met for the portrait. Karsh had moved with his family to Canada to escape Turkish oppression in his native Armenia. 'Good,' said Shaw, 'I have many friends among the Armenians. But the only way to keep them healthy and strong is to have them exterminated every once in a while.'

recreating the effect

Today this style seems a little over-produced. Lighting has become less intrusive; the use of soft boxes as main lights for portraits gives a much more even light across the subject and creates fewer hot spots, which can be seen in this photograph on the head, the glasses and the arm of the chair. However, even with a softer and less theatrical approach, one can learn from the way in which Karsh has used lighting to control the way we look at the portrait. He wants us to follow the line of the chair arm, beginning the diagonal line up towards Shaw's face. He wants to draw attention to the hand holding the glasses and although the background fades to pure black, no part of Shaw is lost in darkness and the line of his shoulders and arms is clearly visible. Whatever style you choose, such attention to detail will pay dividends.

clementina hawarden

Clementina Maude Hawarden, *c.* **1860** albumen print

behind the image

The girl sitting by the window reading is one of the photographer's numerous children, also called Clementina. It is one of a great number of photographs Lady Hawarden took in the studio of her house in Prince's Gate, South Kensington in London, which was at that time newly built. Having caught the bug for photography while living in her husband's ancestral home in Ireland, she turned over a whole floor of the Kensington house to her new hobby when they moved in. With the other side of the street not yet built and gardens behind, the large windows were always flooded with light and she often photographed on the balconies too. Working with so much light allowed her to use relatively short exposure times for the period, ranging from a few to tens of seconds rather than the ten or twenty minutes often required by her contemporary Julia Margaret Cameron for her close-up heads.

The pose, as with many of Lady Hawarden's images, suggests a narrative but does not in fact have one. She entitled these pictures 'studies from life', which aligns them very much with the world of art, and they invite us to speculate on what story might be behind them in the tradition of Victorian allegorical painting. The effect of the subject reading her book by the window draws us in and makes us wonder what her story is. Engrossed in her book it feels as if we are glimpsing a private moment and she is unaware of our gaze.

Placing her subjects next to windows was obviously very useful in terms of lighting them adequately

> **CLEMENTINA HAWARDEN**
> **(1822–1865)**
> Born Clementina Elphinstone Fleeming near Glasgow in Scotland, Clementina's father was an Admiral in the Navy and an active politician. The family was therefore well connected politically and socially and Clementina met and married Cornwallis Maude in 1845, a Captain in the Life Guards. When he succeeded to his title in 1856 she became Lady Hawarden and the family moved to Ireland where she began to take photographs. Moving back to London in 1859 she made many portraits and costume scenes in her Kensington house, often using her children as models. (She had given birth to ten children, eight of which survived infancy.) She first exhibited her photographs at a Photographic Society Exhibition in London in 1863 and then again in 1864. They were widely admired but shortly after she gained acceptance and recognition, she tragically died of pneumonia at the age of 42.

for photography. But this also carries symbolic meaning, representing a desire to escape confinement, an expression of contemplation or a comment on a separation from nature and the natural world. Compositionally, the combination of light flooding in from the window and diagonal shadows thrown across the picture space helps to define the sense of depth and perspective. Using foreground space before her also adds to this, and increases the sense that she is alone and isolated and that we view her unseen.

recreating the effect

Window light is a very effective source for portrait photography, but it is the soft diffused light you need, so make sure your window is not receiving harsh direct sunlight. I would take a spot-meter reading from the subject's face and expose for this. Hawarden has been brave to turn her subject's face away from the light; usually one would make sure the light was falling on her face. A reflector or a softbox would be useful in this situation to throw light back into the face of the sitter and lift the deepest shadows. In fact many of Lady Hawarden's studies of her daughters incorporate mirrors in the picture, which, as well as being useful symbolic and compositional tools, are also very effective reflectors.

john french

Hardy Amies, 1961 gelatin silver print

behind the image

John French made his name as a fashion photographer rather than a portraitist, but his significance lies in his meticulous approach to lighting, as exemplified by this classic, modern-looking portrait of Hardy Amies, who for many years was the Queen's dress designer.

French was largely responsible for changing the emphasis of lighting from a harsh directional style (the classic Hollywood look of the 1920s and 1930s) to one using softer, more diffused sources. The impetus for his innovation was the limitation of commercial printing in the 1950s. Fashion images were confined to expensively printed glossy magazines, such as *Vogue* and *Harper's Bazaar*; newspapers and more cheaply produced journals were forced to stick with

illustrations for their fashion columns due to the coarse and blotchy results of trying to reproduce photographs. French realized that the answer was to reduce the contrast of the images and he therefore lit his subjects with soft, reflected light giving much more even illumination, better, more subtle modelling and lower contrast. If possible, he would use only natural light and bounce the light back on to his models using large white sheets or boards as reflectors. He would also compose with equal attention to detail, avoiding the stark contrast of black placed next to white in favour of subtle compositional and lighting arrangements that placed blacks next to greys and greys next to whites. In this portrait the tonality has been gently manipulated so the darkest area of Amies' hair is set against a pale grey background, but against the mid-grey of his hand, the background is darker. In each case picking out the line and shape, but avoiding high contrast.

French usually worked with a medium-format camera, always on a tripod, although he would not operate it himself, leaving that to one of his many assistants. He would manage his shoots like a film director, working with the model and on the set until he had achieved what he wanted and only then checking in the viewfinder that the camera shared his vision. He would then instruct an assistant to trigger the shutter with the word, 'still'.

JOHN FRENCH
(1907–1966)
Born in London, John French studied at the Hornsey School of Art. After some years working as an artist in Italy, he returned to England and worked as a set designer for advertising photography, gaining crucial experience in lighting and art directing. During World War II he served as an officer in the Grenadier Guards and on returning to civilian life, set up his own photographic studio. Using natural and diffused lighting he developed a distinctive style for fashion photography that would became the industry norm. He also nurtured future talent through the employment of a series of photographic assistants, most notably Terence Donovan and David Bailey.

recreating the effect

Today a portrait like this would be best achieved on a medium-format camera with a 120mm lens opened up to a wide aperture to achieve the shallow plane of focus on the face, with the cigarette and smoke atmospherically left out of focus. French may have achieved his lighting effects with reflectors but in addition to the main light source, the background would need illuminating and a further light added to the hair.

nadar

Nadar in conversation with M-E Chevreul and his laboratory director, 30 August, 1886 albumen print

behind the image

One of the great innovators and leading portraitists in early photography, Nadar came out of semi-retirement to take this rather unusual portrait of himself in conversation with the celebrated French scientist Michel-Eugène Chevreul on the occasion of his 100th birthday. The figure at centre back is Chevreul's laboratory director. It is entirely in character with the flamboyant and self-promoting Nadar to use himself as interviewer and it is in fact his son Paul who operates the camera, but the fact that this portrait is designed to illustrate a conversation is its key. It is one of a sequence of 27 images, constituting a discussion between the scientist and the photographer; an innovative attempt on the part of Nadar to make photography animate a well known figure and demonstrate something of his personality and force of character alongside the dialogue.

Nadar had been instrumental in bringing celebrity faces to the French public through the many portraits he made of the leading cultural and artistic figures of the day such as the poet Baudelaire, artists and musicians such as Edouard Manet, Hector Berlioz and the celebrated actress Sarah Bernhardt. In an era when celebrity meant people knew your name but not what you looked like, Nadar made them famous faces by pioneering the sale of his portraits to the general public.

Creating a sequence of images and adding words gives additional meaning to the portrait and, like a cartoon strip, there is the opportunity for the images to demonstrate different expressions, building up a picture of the sitter's personality. Nadar's innovation anticipates the idea of a picture story and photojournalism which was to become such an important part of 20th-century photography.

NADAR
(1820–1910)
Gaspard-Felix Tournachon earned the nickname Nadar when he was working as a caricaturist. He turned to photography in 1853 opening a portrait studio in Rue St Lazare, Paris, with his brother Adrien. Nadar's energetic personality had made him a well-known character in Paris's bohemian artistic and literary circles and his associations meant that he could photograph many of the best known personalities of the day who were his personal friends and acquaintances. This had the added benefit of his being able to sell these prints to the general public who had little or no access at that time to images of well-known people. Commercial success allowed him to move to large new premises in the Boulevard des Capucines but during the 1860s his interest waned and he left much of the portraiture to assistants. A great innovator, he was the first aerial photographer, going up in a balloon to photograph Paris in the late 1860s. He was also a pioneer of artificial lighting making studio portraits and photographing the Catacombs and sewers of Paris using battery-powered lights.

recreating the effect

Being able to take a sequence of pictures frees you from the difficult job of getting a single frame portrait to say everything about your sitter – giving the viewer sufficient information about their physical characteristics and, hopefully, some insight into their character. If you can take a sequence of frames you can capture fleeting expressions and gestures which in a single image could be distracting but when viewed together build up a much more natural impression of your subject's character. There is no substitute in this case for shooting lots of film and attempting to capture unguarded moments rather than trying to control the pose of your sitter. An old trick in a set-up portrait is to keep shooting when your subject thinks the shot is done and instinctively relaxes.

edward steichen

Gloria Swanson, 1924 gelatin silver print

behind the image

A celebrity picture of a famous film star… but Steichen has incorporated the well-known face into a decorative scheme by the simple technique of shooting through a layer of patterned fabric or lace. The composition includes Gloria Swanson as one of its elements but is not entirely 'of' her. The fabric has the effect of flattening the photograph so it appears to work only in two dimensions and the features of Swanson's face intermingle with the swirling pattern, so that in parts the patterning could be part of the model and the face is therefore drawn into the pattern.

EDWARD STEICHEN
(1879–1973)
Born in Luxembourg, Steichen moved to America as an infant with his family. At the age of 16 he taught himself photography and during his early career became associated with the Pictorialist style of photography, attempting to emulate a painterly aesthetic. In 1905, along with Alfred Stieglitz, he founded the famous 291 Gallery on Fifth Avenue in New York and increasingly became influenced by the abstraction and fragmentation of the new art movements. Steichen was appointed to command the photographic division of the U.S. Expeditionary Forces in World War I, then during the 1920s and 30s he worked as a commercial photographer for, amongst others, *Vogue* and *Vanity Fair*. In World War II he was appointed to direct the Naval Photographic Institute, and from 1947–62 was Director of the Department of Photography at the Museum of Modern Art in New York where he had a profound influence on the history of photography, notably through the famous 'Family of Man' exhibition in 1955.

Steichen was instrumental in developing the 'new look' for fashion and celebrity photography in the 1920s when he took over as chief photographer for Condé Nast publications, the publisher of *Vogue* magazine. Using patterned fabrics and props, he developed a style emphasizing geometric shapes and decorative design rather than the more romantic portrayals of fashion that had been the style up until the 1920s. Such a move was in line with developments in the other arts, the feeling for Modernism placing increasing emphasis on line and pattern as a way of portraying the brave new world of machines and Modernist architecture.

Apart from the compositional effect of the patterning, the fabric lends an exoticism and even an eroticism to a portrait of one of the world's most beautiful and desired women. Great beauty glimpsed through a veil makes her untouchable and yet alluring as her piercing eyes invite us to imagine what we might see when the veil drops. Steichen's flat composition keeps both the veil and the model's face in a shallow focus, so she would have been very close to it. Keeping only enough depth of focus to hold the face and veil, the plain background naturally drops out of focus, appearing flat, and does not distract from the face.

recreating the effect

Putting Vaseline on the lens to create a misty soft-focus effect on a face that you want to beautify or idealize has long been a portrait photographer's trick, and Steichen has taken that one step further with this picture, not simply diffusing the image but adding pattern. To try the same you need a fabric that is sufficiently transparent to shoot through and you need to pull it taught so that there are no folds to distract the viewer, or to create ripples and unwanted shadows. Open the lens up so that you have a very shallow plane of focus which you can train on the face and fabric, emphasizing the two-dimensional effect. The compositional idea of shooting through a pattern or texture could also be applied much more generally, using wire, mesh or chain-link fences or goal nets (as you often see in sports photography).

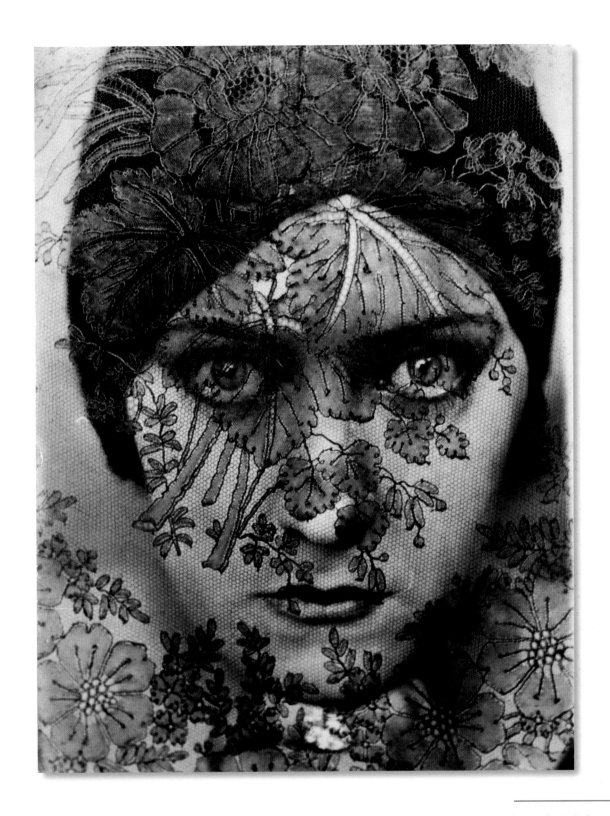

david bailey

André Kertész, 1980 gelatin silver print

behind the image

David Bailey is known for his simple, direct black-and-white portraits, usually with a pure white background; it is a style often copied but never bettered. Who can forget his iconic pictures of Jean Shrimpton, Michael Caine and The Krays – all classics of their type. Unlike his famous portraits of actors and models, here he has departed from his trademark white background for a portrait of one of the true greats of his own profession, photography. Using a 120mm lens on a Hasselblad camera (probably with a correction prism on the top of the camera to turn the image the right way up in the viewfinder) Bailey has concentrated attention on Kertész's features in a narrow strip of light, bounded by his hands and the deep shadows they cast. The main light comes from the right, creating strong shadows on the left of his face and leaving his right shoulder in darkness. There would also have been a light that was trained on the background.

It looks like one of those days when things are not going a hundred per cent right – we all have them. Kertész, a great hero of Bailey's, looks a bit grumpy and as if he might not be entirely happy with Bailey's directions. But nevertheless, between them they have made a great picture. Interestingly, for the last 25 years Bailey has avoided including hands in his portraits; maybe this session convinced him they were not worth the trouble. Bailey may have been nervous to be photographing one of the world's great photographers but it would be hard to believe – he is a very strong character, particularly in his own studio. Not one to be impressed by reputation, there have been a few notable sitters over the years who have been asked to leave because they were not 'giving' him anything.

recreating the effect

Hands are always difficult to work with in portraiture – they can often look as though they are stuck on, so pay close attention to them before tripping the shutter and try to get them as elegantly and naturally posed as possible. The classic Bailey portraits were taken with a 120mm lens on a Hasselblad camera, but the effect is achievable with any camera. Use a medium-length telephoto lens to give the portrait more intensity and light the background separately. For a pure white backdrop, take a separate meter reading from the background – as long as it is at least one stop brighter than the subject it will record as featureless white. You can vary the intensity of the light on the face by moving it closer or further away from the subject. Dodging and burning in the darkroom or in Photoshop can then remove further detail to achieve the high contrast black-and-white effect. The use of a pure white background in a portrait tends to open up a face, whereas black backgrounds do the opposite and give a feeling of enclosure.

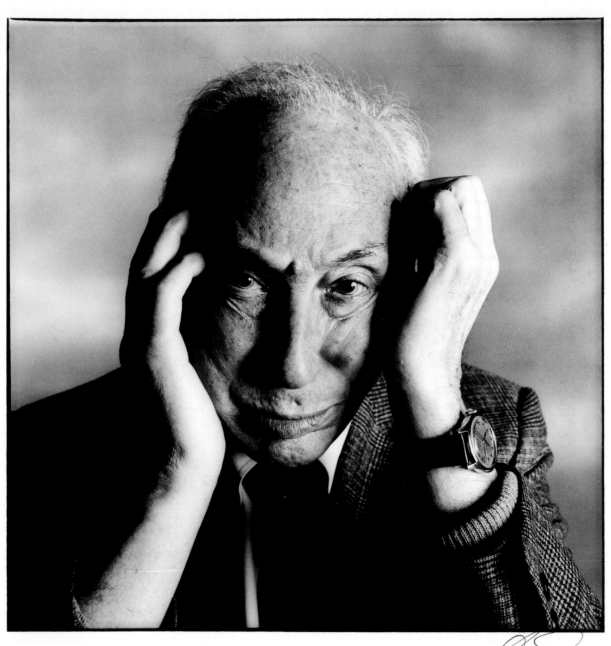

robert demachy

Figure Study from an Etched Negative, 1906 gum bichromate

behind the image

This beautiful portrait appears hardly to be a photograph at all, but looks more like a charcoal sketch or a lithographic print. This is exactly the effect Demachy was trying to achieve and he did so by etching the negative, adding painterly strokes so that the final print has much more the effect of 'art' (or at least as it was understood in 1906) than it has of straight photography.

Demachy was one of the leading early exponents of Pictorialism which was the dominant trend in photography from the late 19th century until early in the second decade of the 20th century; it sought to align photography with art rather than mechanics, beauty rather than fact. Partly as a reaction to the simplification of the photographic process with the introduction of the dry plate, aesthetic photographers wanted to find ways to differentiate their work from the thousands of mechanical record photographs that were increasingly cheap and easy for anyone to execute. In Demachy's case this meant the artist intervening in the process with his own hand. The etching of the negative is a decisive intervention but Demachy was also a leading promoter of the gum-bichromate printing process which had

ROBERT DEMACHY
(1859–1937)
Born into a wealthy Parisian family, Robert Demachy became a leading champion of Pictorialist photography, manipulating the photographic process to create more painterly results. He founded the Photo-Club of Paris and was a member of the Linked Ring group of photographers. He photographed a diverse mix of subjects including portraits, street scenes and figure studies. Ballet dancers were a favourite subject and he created a number of romantic images of them which are closely reminiscent of Degas' paintings and drawings of the same subject. He was also a strong spokesman for the cause of photography as art and wrote many articles and books on the subject.

been discovered back in the 1850s and since then largely abandoned. This involved painting on to ordinary paper a photo-sensitive emulsion mixture of gum arabic, potassium bichromate and a coloured pigment, which then hardened in proportion to its exposure to light. The less exposed areas – the unhardened areas of the gum – would dissolve in water, thus revealing the image. The advantage was that a greater range of colour and tone was available to the photographer, and it was also possible to intervene in the development process to encourage localized dissolving of the emulsion for subtle tonal effects.

recreating the effect

Today, ironically, filters in Photoshop allow you to turn any image into a pencil sketch or a watercolour painting at the click of a mouse, but such treatments are generally looked down upon as cheap and artless. It is of course possible to do the same job in a much more subtle and sophisticated way with expert use of computer programs, and this would be the most effective way to recreate the look of Demachy's image. Using liquid emulsion in the darkroom you can still paint on to photographic paper in much the same way as with the gum bichromate, and this too can give effects reminiscent of hand-drawn art – particularly using pale tonality in black and white. Demachy would have been using large glass plate negatives and so the job of manually altering them was far easier than it would be using modern film, and certainly small 35mm film which most people use today. No doubt it would be possible to etch the film but very hard to obtain any subtlety at such a small scale.

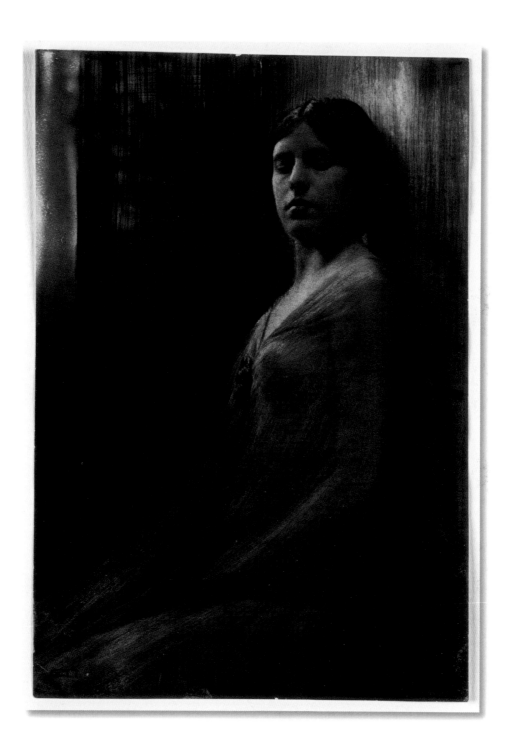

alexander rodchenko

Varvara Stepanova, 1928 gelatin silver print

behind the image

One of the most influential artists of the early 20th century, this portrait is typical of Rodchenko's use of challenging and unusual angles and unexpected views. The subject is Varvara Stepanova, an important artist in her own right and also Rodchenko's wife. Both were leading members of the Constructivist movement, a group of Russian artists who, influenced by Cubism and Futurism, sought to create a new means of artistic expression that would be in tune with their modern, industrial, post-revolutionary world.

ALEXANDER RODCHENKO
(1891–1956)

Born in St Petersburg, Russia, Rodchenko was one of the most influential artists of the early 20th century. A follower of Tatlin and Malevich, he used a wide variety of media as a decorator, designer, painter, sculptor, printer and photographer; he also wrote and taught in Moscow. Best known as a key member of the Russian Constructivists movement alongside artists such as Vasily Kandinsky, Naum Gabo, and El Lissitzky, he co-wrote the Constructivists' manifesto in 1921. Influenced by his work in illustration and commercial design, he turned to photography in 1924 most notably using photomontage techniques. He developed a trademark style of unusual and unexpected camera angles but was criticized for 'formalism', and eventually gave up photography in the early 1940s, returning to painting.

Rodchenko initially used photography in collages and montages, the mass-produced nature of the images chimed with the anti-élitist flavour of the times. The relatively unskilled technique also made it seem a fitting way to create a new art for the working class and show them the new socialist way of life. He turned exclusively to photography from 1924 as the best means of fulfilling his artistic goals (the camera is, after all, a machine of sorts) and developed a style of straight photography using the strong graphic shapes and diagonal compositions characteristic of his collages and graphic design, but instead using unusual angles and unexpected high or low viewpoints.

The defining features of his photography are stark tonal contrast and diagonal forms – often using the structures of brick and steel. Applying his techniques to portraiture, the subject becomes part of the composition, treated objectively as if it were inanimate, just another machine or construction.

However, despite Rodchenko's genuine belief in the ideals of the Revolution and his will to give them artistic expression, in the uncertain world of Stalinist Russia he came under attack by the authorities for

recreating the effect

Rodchenko has subverted the portrait so that his photograph is not about a natural rendering of the subject, but rather uses the human face as a building block in his composition. The usual goal of a portrait is to give an accurate record of the subject, hopefully to reveal something of their personality or occupation (perhaps with a prop) and make the most of his or her physical appearance. To achieve Rodchenko's aims, these concerns are disregarded and the subject is treated as just one part of many in a formal composition; any further information about the subject is subtly imbedded within it.

'bourgeois formalism'. Denounced for the first time in 1928, the year from which this photograph dates, Rodchenko was forced to admit his errors and his creativity was stifled over the next decades. In the light of this, the sense of restriction that he has created in this portrait of a fellow artist and the shadow of the constraining net, falling like bars on her face, give it a power beyond its formal compositional qualities.

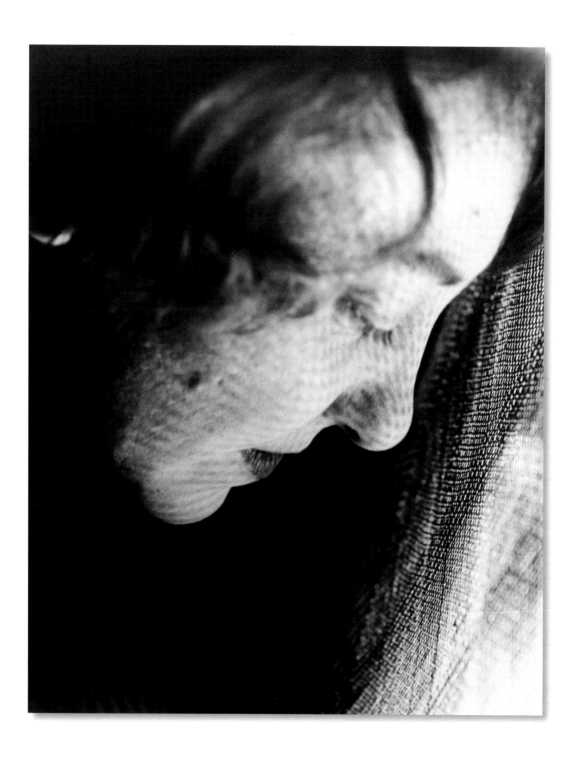

david hockney

My Mother, Bolton Abbey, Yorkshire, 1982 photographic collage

behind the image

This portrait of the artist's mother is typical of a style of portraiture that Hockney pursued throughout the 1970s and 80s. Known as an artist rather than a photographer, Hockney had been using Polaroids to plan a painting. Creating a collage using many different photographs to help him work out his composition, he noticed that the pictures held together as a single entity and also revealed additional aspects, different angles and movement that he could not capture in a painting.

Using the most basic cameras, Hockney's 'joiners' contain anything from five to more than a hundred individual photographs, usually taken with a Polaroid camera or a basic compact model and produced using standard photolab prints. In this portrait of his mother, Hockney has moved around the subject slightly, including different angles and even showing his own feet at the bottom of the composition. He confirms his own role in the process, making us aware of his presence in the scene and showing that he has a relationship with his subject.

Each image is necessarily taken at a slightly different time and either from a marginally different position, or things have moved a little within the frame. Building up a single 'scene' from these slightly changing viewpoints gives a feeling of movement and narrative and allows things to be shown that might otherwise have been hidden in a single perspective. Elements can be drawn out for emphasis, like the gravestone which is picked out with a close-up.

> **DAVID HOCKNEY**
> (1937–)
> Hockney was born in Bradford, Yorkshire and won a scholarship to the local grammar school where he developed his interest in art. He attended Bradford School of Art and then the Royal College of Art in London where he was awarded a number of prizes. Moving to California at the end of 1963 he embarked on a series of brightly coloured paintings of swimming pools, the most famous of which, *A Bigger Splash* was also the title of a 1974 documentary film about him which cemented his fame. Hockney is also known as a draughtsman and print maker and began working with photography in about 1970 producing a number of his 'joiners', collaging Polaroids or photolab prints, throughout the 1970s and 80s. He has also produced operatic stage sets and costume designs, notably for the Glyndebourne productions of Stravinsky's *The Rake's Progress* and Mozart's *The Magic Flute* in 1975 and 1978.

Hockney disliked the vogue in photography for wide-angle lenses, preferring the standard lens which represents the subject as the eye would naturally see it. Another interesting aspect of these joiners is the way in which every constituent part of the image is in focus – from the far background to Hockney's feet – again replicating the experience of looking at something with your own eyes. This wouldn't be the case with a single image.

recreating the effect

This would be a great and simple project to do yourself. Just choose your subject and fire off a roll of film – move yourself around it to capture hidden angles and reveal shapes that would be hidden or flattened in the perspective of a fixed viewpoint. This is not a style of photography with which to get hung up on technical photographic problems; just shoot the pictures and start building up your montage. With modern digital cameras it is even quicker and easier to shoot a hundred frames from which to build a joiner and then edit before printing out the ones you want, or even build up the whole composition digitally on the computer.

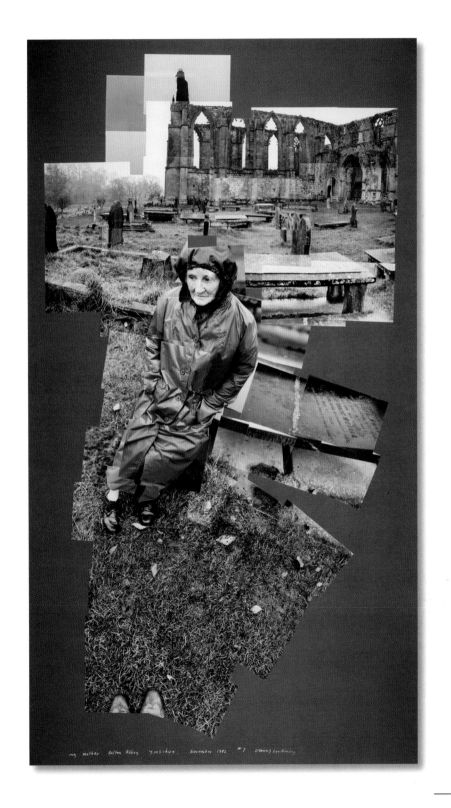

my mother Bolton Abbey Yorkshire. November 1982 #7 david hockney

glossary of photographic processes

albumen print

The print most commonly used in the 19th century was invented by Louis-Désiré Blanquart-Evrard in 1850. The paper was prepared by coating a thin sheet with a mixture of albumen (in the form of egg white) and sodium chloride or ammonium, which was left to dry, giving a glossy surface. At first photographers coated their own paper, but by the mid-1850s it could be bought ready-coated. It was made light-sensitive by coating it with silver nitrate, after which it needed to be dried in the dark. The print was made by placing the treated paper in contact with a negative in a printing frame and leaving it to react, usually in the sun. Albumen prints are identifiable by their mellow purple-brown tones, richness of detail and creamy, luminous highlights, although many have yellowed over time due to a protein-sugar reaction in the albumen coating.

ambrotype

Following the development of the collodion wet-plate negative process, James Ambrose Cutting patented the ambrotype, or collodion positive, in 1852. It was discovered that an underexposed, developed wet-plate negative would appear as a positive image when placed against a background of black cloth, paint or varnish and viewed by reflective light. This offered a cheaper alternative to the daguerreotype (p138), although it lacked its brightness and tonal range. The image was presented by enclosing it in an airtight case under glass, and was often hand-coloured.

autochrome

The autochrome was the first really usable colour photographic process, invented and patented by Louis Lumière in 1904. It used a glass plate that was coated with varnish and then with a layer of microscopic transparent potato starch grains dyed red, blue and green and randomly mixed to create a coloured mosaic. The final coating was a light-sensitive emulsion. The plate was inserted in the camera with the emulsion at the back, so that light passed through the grains, which acted like filters, selectively exposing the emulsion. Viewed against the light, the coloured grains in combination with the black-and-white photograph produced the effect of a colour image. The softness and beauty of the colours made the process popular for studies of domestic subjects such as children and flowers.

bromide print

A normal black-and-white photographic print. Bromide paper originally contained only (or mainly) silver bromide as the light-sensitive material, which gave the photograph neutral or cold black tones.

bromoil print

A method for turning bromide prints into pigmented prints, which became known as the bromoil process, was published in Britain in 1907. It is a form of oil printing, based on the principle that oil and water do not mix. A low-contrast bromide print, made on paper with an unhardened emulsion,

is treated with a solution of potassium dichromate; the silver image is bleached out and the gelatin hardens in proportion to the amount of silver removed. The bleached print, or matrix, extensively washed and dried, is soaked so that the unhardened areas of gelatin absorb water. When oil-based ink is applied it adheres better to the drier areas, and the image reappears, with pigment replacing the silver. The ink is applied using brushes, giving the photographer great control over colour and tone.

calotype, or talbotype

This process was the beginning of photography as it is known today, producing a negative from which an infinite number of positives could be made. Following his earlier experiments with photogenic drawing, which used light-sensitive paper and bright sunlight to create images of leaves and other objects, William Henry Fox Talbot invented the calotype in 1840 and patented it the following year. Thin writing paper was brushed with silver nitrate, then floated in potassium iodide and given a coat of weak silver nitrate, acetic and gallic acid, which acted as a developer, creating a surface far more light-sensitive than that used in photogenic drawing. This made possible exposure times as low as 30 seconds in bright sun. The paper was exposed in a camera and developed to produce a negative. The negative, or calotype, was then placed in a contact printing frame against another sheet of sensitized paper and exposed in sunlight to produce a positive image, known as a salt print. The prints had a rather rough texture because the fibres of the paper negative were reproduced in the final image. By the late 1850s, paper negatives had been superseded by glass plates, which avoided this problem, and the calotype process fell out of use.

carbon print

The carbon print, or autotype, was patented in 1864 by Joseph Wilson Swan, who based the technique on the research of Alphonse Louis Poitevin. It is a contact process that uses carbon tissue, made by coating thin paper with gelatin and finely powdered carbon or other pigment. When sensitized with potassium dichromate, the gelatin hardens in proportion to the amount of light reaching it. The tissue is placed in contact with a photographic plate and exposed to light, then pressed, carbon side down, on to a sheet of paper or other printing surface. The tissue and gelatin are washed away, leaving the carbon image. The resulting print has a matt finish and subtle tonal gradations, and is resistant to fading.

carbro print

A drawback of carbon printing, as a contact process, is that it requires large negatives to make large prints. For carbro printing, introduced as the ozobrome by Thomas Manly in 1905, a bromide print is made first, using paper with an unhardened emulsion. This print is brought in contact with carbon tissue sensitized with a solution that bleaches the silver in the bromide print: this chemical reaction hardens the gelatin on the tissue. The final image can then be produced in the same manner as a carbon print. The bromide print can

be redeveloped and the process repeated to make further prints. Tricolour or trichrome carbro prints were made from 1919 to about 1950, using three 'separation' bromide prints made by photographing a subject or colour image through red, green and blue filters; the three transfers created from these were then stacked together to produce a permanent colour print.

collodion process (*see wet collodion process*)

collotype

Like the carbon print, the collotype arose from the work of Alphonse Louis Poitevin, and was introduced by Josef Albert in 1868. It is a photomechanical process capable of rendering continuous tone and fine detail. A glass plate is coated in gelatin sensitized with potassium or ammonium dichromate, and then exposed to light in contact with a photographic negative. The gelatin hardens in proportion to the amount of light reaching it and the plate is then washed and dried. To print, the plate is dampened and then inked with oil-based ink, which adheres to the hard, dry areas and is rejected by the soft, water-absorbent areas. Paper is placed on top of the plate and pressure applied using a lithographic press or hand roller.

combination print

Combination printing is the technique of using more than one photographic print or negative in conjunction with one another to create a single image. This was popular in the mid-19th century due to the limitations of camera technology and the light sensitivity of the negatives. For instance, when a photograph was taken of a landscape, the sky appeared almost blank with very little detail because the negatives used were highly sensitive to blue. Hippolyte Bayard was the first to suggest combining two separate negatives, one of the subject matter, and a properly exposed negative of clouds, to create a balanced photograph. This could be achieved in the camera, by multiple exposure, or in the enlarger, by sandwiching or multi-printing negatives. Combination printing caused great controversy in the photographic community in the mid-19th century. Photographs had previously been thought of as showing truth and the camera never lied. However, with the ability to manipulate the final product, it shattered the notion that photographs depicted 'truth'.

c-type print

A c-type or chromogenic print is a standard print made from a colour negative, either by hand printing or machine printing. Using a process introduced in the 1950s, the images are formed on paper coated with three layers of emulsion, each sensitized to one of the primary colours (red, blue and green). During printing, chemicals added to the paper form tiny globules of dye of the appropriate colours in the emulsion

layers. C-type prints are sometimes labelled as 'colour coupler prints' in galleries, named after the chemicals used in the development process. Until recently c-type prints deteriorated in around 10–20 years even if protected from light, but modern papers and inks are greatly improving their life expectancy.

cyanotype

The cyanotype or blueprint process, patented by Sir John Herschel in 1842, uses a light-sensitive emulsion of iron salts painted on to paper and exposed by contact. Any unexposed emulsion is washed off with water. The resulting deep blue print is very stable, and was long used to reproduce architectural and engineering drawings.

daguerreotype

The first commercial photographic process was launched by Louis Jacques Mandé Daguerre in 1839, using silver-coated copper plates sensitized with mercury vapour. It produced a delicate mirror image of the subject as a film of mercury-silver amalgam on the surface of the plate. At first exposure times of 15–20 minutes were needed, though this was later reduced sufficiently to enable portraits to be made. The light-sensitive silver was stabilized by soaking in salt solution but remained fragile and subject to atmospheric damage, so the plates were sealed behind glass and preserved in decorative cases. Daguerreotypes were popular for portraiture, as the images were clear and detailed, but by the 1860s they had been superseded by systems using negatives, which could produce multiple prints.

dry plates

Gelatino-bromide dry plates – glass plates coated in an emulsion of gelatin and light-sensitive silver salts – were introduced in the 1870s. They were called dry plates to distinguish them from the wet collodion plates in use at the time. At first photographers bought the emulsion and coated their own plates, but ready-made dry plates became widely available from 1880 and continued in use until the advent of film. Dry plates eliminated the need for portable darkrooms and were more light-sensitive than wet plates, enabling faster shutter speeds to be used.

dye transfer print

In this method of colour printing, first used in 1925, a colour negative or transparency is photographed three times using red, green and blue filters. The resulting separation negatives are used to produce three matrices on gelatin-coated film, which hardens selectively. Dyes in the relevant subtractive colours – cyan, magenta and yellow – are applied to the matrices and transferred to paper one at a time, in precise registration, to create a stable print with rich, luminous colour.

gelatin silver print

The standard black-and-white print is made on paper coated with an emulsion of gelatin and light-sensitive silver salts. The final image consists of metallic silver embedded in the gelatin coating. The paper was introduced in 1882, and gelatin silver prints quickly replaced albumen prints (p135) because they

were more stable and easier to produce. Silver bromide paper, which produces neutral tones, is the most generally used. Silver chloride, used for contact prints, gives cool bluish tones, and silver chlorobromide gives warm brownish tones.

gum bichromate print

This printmaking technique, popular in the 1890s, was based on the fact that gum arabic sensitized with potassium or ammonium dichromate (formerly bichromate) hardens on exposure to light. Paper was coated with an emulsion of sensitized, pigmented gum arabic and exposed through a negative. This selectively hardened the surface of the print, which was then washed or brushed by the photographer to remove the unhardened gum, leaving a permanent image formed by the pigment in the hardened areas. Further colours could be added to the print by repeating the procedure. The technique produced broad-toned prints lacking fine detail.

kallitype

The kallitype process produces prints that are indistinguishable from platinum prints but much cheaper. It is based on the light sensitivity of ferric iron salts, which are reduced to form an image of silver. The basic theory was outlined by Sir John Herschel in 1842, but the first iron-silver process was patented by W W J Nicol in 1889. Paper coated with a solution of ferric oxalate and silver nitrate is exposed to sunlight in contact with a photographic negative, then developed, fixed, washed and toned. Varying the developer used in the process results in a range of different tonalities.

palladium print

Similar to a platinum print but generally warmer in tone, a palladium print or palladiotype is made using paper coated with iron salts combined with a compound of the metal palladium. It was adopted as a cheaper alternative to platinum in the 1920s.

photogravure

This photomechanical method of engraving was invented by the Austrian printer, Karel Klic, in 1879, using the carbon tissue devised by Joseph Wilson Swan for carbon printing. Once the tissue has been exposed in contact with a photographic plate it is pressed on to a copper printing plate and the backing paper and unexposed gelatin are removed. The hardened gelatin acts as a resist when the plate is placed in an acid bath, so that the image is etched to depths corresponding to the tones of the original photograph. The resulting print shows very fine detail, and the technique was widely used for the reproduction of photographs from the 1890s.

platinum print

Photographic paper prepared with platinous potassium chloride and iron salts was sold by the Willis Platinotype Company of London from 1879. Potassium oxalate developer reduced the platinum salt to pure platinum, giving beautiful prints with a very wide tonal range and a very long life. However, the price of platinum rose sharply between 1910 and 1920, making the paper extremely expensive, and production

ceased in 1941. Platinum printing is a contact process, so large negatives are required, and it needs an ultraviolet light source, such as the sun or a mercury vapour lamp.

polaroid print

Polaroid photography was invented by American physicist Edwin Land. In 1947 he demonstrated a single-step photographic process that enabled photographs to be developed in 60 seconds. Land then founded the Polaroid Corporation to manufacture his new camera which was first sold to the public in 1948. The original process that Land developed involved a negative material being exposed inside the camera, which was then drawn out whilst being squeezed against a layer of reagent and a positive material. After 60 seconds, the layers could be separated and the negative discarded. In the current Polacolour process, light makes a series of latent images on appropriate dye layers of the film sheet; when the picture is ejected from the camera, processing reagent activates the image in these lower layers, which reaches final form in several minutes. The resulting print is protected by a hard plastic film.

salted paper print

The salted paper, or salt print was the first positive print, produced by William Henry Fox Talbot from his calotype (p136) negatives in 1840. Writing paper, sensitized with salt and silver nitrate, was exposed to sunlight in contact with the negative, then fixed with sodium thiosulphate, washed and dried. It could also be toned with gold chloride. Because the paper is uncoated, the result is matt. Salted paper prints are reddish or purplish brown, but are very sensitive to atmospheric pollution and susceptible to fading.

talbotype
(see calotype)

tintype

Local and travelling photographers sold tintype, or ferrotype, portraits for many years because they were cheap, easy and quick to produce. The process was introduced in the 1850s and was still being used in some countries a century later. Derived from the ambrotype, the tintype was a negative that appeared positive when viewed against a dark background. The image, laterally reversed like a daguerreotype (p138), was made on a very thin sheet of iron (not tin) covered with sensitized collodion.

wet collodion process, or wet plate

Frederick Scott Archer patented the wet-plate negative, or wet collodion, process in 1851. Collodion was a solution of guncotton in ether or alcohol, which was mixed with potassium iodide. This syrupy liquid was poured on to a glass plate and, when it began to set, was sensitized in a bath of silver nitrate. The plate was then exposed in the camera

and developed immediately, while still wet. This meant that a
darkroom had to be set up wherever a photograph was to be
taken, and the process was messy and fiddly. Despite this, it
was almost universally adopted until about 1880, when gelatin
dry plates became generally available. Photographers preferred
it to calotypes (p136) or daguerreotypes (p138) because the
use of glass rather than paper negatives produced grain-free
images, exposure times were as little as a few seconds, and
the collodion could render very fine detail and a good range
of tones.

woodburytype

Patented in 1864 by Walter Bentley Woodbury, this
photomechanical printing process was developed to create
continuous tone images. It was used until about 1900, mainly
for fine quality book illustration. As in the collotype process, a
layer of dichromated gelatin was exposed in contact with the
negative and hardened in proportion to the amount of light
reaching it. The gelatin that remained soft was washed away
and the resulting mould was pressed into a soft lead sheet
– an operation that required enormous hydraulic pressure – to
make a reversed mould that could be filled with pigmented
gelatin for printing. The prints were made on a hand press.
The image was formed in pigmented gelatin with the thickness
of the layer creating darker and lighter tones, giving luminous
results and faithful reproduction.

photographic acknowledgments

All the prints reproduced are held in the collection of the National Museum of Photography, Film & Television in Bradford, Yorkshire.

Reproduced courtesy of the National Museum of Photography, Film & Television / Science & Society Picture Library: 17, 31, 37, 41, 47, 63, 73, 83, 97, 105, 119, 123.

Reproduced courtesy of the Royal Photographic Society Collection at the National Museum of Photography, Film & Television / Science & Society Picture Library: 23, 27, 29, 43, 53, 59, 69, 77, 79, 91, 93, 99, 109, 113, 117, 129.

© George Rodger / Magnum Photos: 19; FSA / Farm Security Administration: 21; courtesy Don McCullin: 25; Robert Capa © 2001 by Cornell Capa / Magnum Photos: 35; © Josef Koudelka / Magnum Photos: 45; Hulton Archive / Getty Images: 39, 49; courtesy John Blakemore: 55; courtesy Estate of Margaret Bourke-White: 57; courtesy Anna Fárová, Josef Sudek Estate: 61; © 1971 Aperture Foundation Inc. Paul Strand Archive: 67; used with permission of the Trustees of The Ansel Adams Publishing Rights Trust (all rights reserved): 71; Collection Center for Creative Photography, The University of Arizona © 1981 Arizona Board of Regents: 81; courtesy Paul Caponigro: 85; André Kertész Estate: 89; © Estate of the Artist, courtesy Gallery Kicken, Berlin 87; Estate Brassaï RNM: 95; courtesy Estate of Manuel Alvarez Bravo: 101; Nickolas Muray Photo Archives: 107; courtesy Cecil Beaton Archive, Sotheby's, London: 111; courtesy of Horst P Horst Estate: 115; V&A Images / Victoria & Albert Museum: 121; reprinted with permission of Joanna T Steichen: 125; © David Bailey: 127; © DACS 2005: 131; © David Hockney: 133.

All attempts have been made to trace and clear copyright prior to publication. The publishers will be pleased to rectify any inadvertent omissions in future editions.

acknowledgments

Thanks to everybody at David and Charles especially my editor Neil Baber who always knew what I meant to say and whose knowledge of art history was a great asset. I am also grateful to the helpful staff of the National Museum of Photography, Film & Television and the Science and Society Picture Library, in particular Damon McCollin-Moore, Brian Liddy and Chris Rowlin.

Thanks also to my wife Rebecca Smithers for putting up with me while I was researching the book, to Beth Elliott for keeping the studio working while my head was elsewhere, to Alan Rusbridger who started me writing on photography in the first place and Roger Tooth of *The Guardian* for his support and to Mark Polyblank, great photographer, neighbour and a man who knows everything.

Finally my thanks to John Blakemore and Peter Goldfield who always made photography so easy to understand and to Don McCullin and David Bailey who inspired me.